THIS
IS
HAPPEN
ING

D0000332

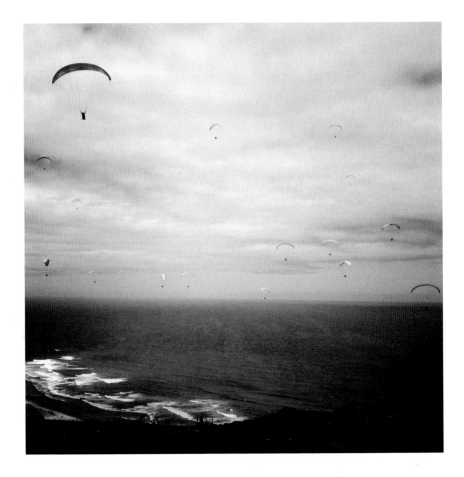

THIS IS HAPPEN ING

#Life Through the Lens of Instagram

Edited by Bridget Watson Payne

CHRONICLE BOOKS

SAN FRANCISCO

All the photographs in this book were submitted by their individual photographers in response to a call for entries. Submissions were reviewed by the Chronicle Books photography book team. All photographers retain full ownership and copyright of their images, and all images are used by permission of the individual photographers.

Library of Congress Cataloging-in-Publication Data available.

ISBN: 978-1-4521-2335-6

Manufactured in China.

Design by Brooke Johnson.

Front cover art by (left to right and top to bottom): @leannxli, Leann Li / @stylepic, www.stylepic.de / @girlsnogood, Sophia DiPersio / @maestroechoplex / @caraluna, Tonya Becerra, www.caralunastudio.com / @zenguin, www.guineveredelamare.com / @katherinelightner, www.blog.katherinelightner.com / @bay2, Bayle Doetch, www.lovefromthebay.blogspot.com / @juliegeb, Julie Gebhardt / @her_fork_in_the_road, Lisa S. Bach, www.herforkintheroad.com / @bay2, Bayle Doetch, www.lovefromthebay.blogspot.com / @inwardfacinggirl, Melanie Biehle, www.inwardfacinggirl.com / @tinafchan, Tina F. Chan / @tinafchan, Tina F. Chan / @melbpart3, Melody Baker, www.melbpart3.typepad.com / @skerry000, Shelly Kerry, www.creatingspacemindfulliving.com.

Back cover art by (left to right and top to bottom): @girlsnogood, Sophia DiPersio / @paperandhoney, Laura Joseph, www.paperandhoney.com / @juliegeb, Julie Gebhardt / @smallroots, Adriana Botello, www.smallroots.com / @brookej3000, Brooke Johnson / @bay2, Bayle Doetch, www.lovefromthebay.blogspot.com / @cjwords, Christopher-James Robert Warrington, www.cjwarrington.com / @ben_mc_carthy, Ben McCarthy / @nicoletogo, www.about.me/nicolevas / @jainny, Jane M., www.jainny.com / @mackanna, www.kooshoo.blogspot.com / @bay2, Bayle Doetch, www.lovefromthebay.blogspot.com / @thegreengal, Gabrielle Treanor, www.thegreengables.co.uk / @brittanymarcoux, www.brittanymarcoux.com.

Spine art by (top to bottom): @meghandavidson, www.meghandavidson.com / @donavanf, Donavan Freberg, www.donavanfreberg.com.

10 9 8 7 6 5 4 3

Chronicle Books LLC
680 Second Street
San Francisco, CA 94107

www.chroniclebooks.com

We are the users of Instagram and we made this book.

We see something we otherwise might have missed. It makes us happy.

We almost can't believe our eyes. Is this really happening? Yes! This is happening!

We grab our phones and we shoot.

We make everything dreamy and vintage and beautiful.

We share. We share and share and share.

We commune with people down the hall, and on the other side of the world.

We look. We smile. We laugh. We are astounded. We maybe even get a little misty-eyed.

We like. Oh, how we like.

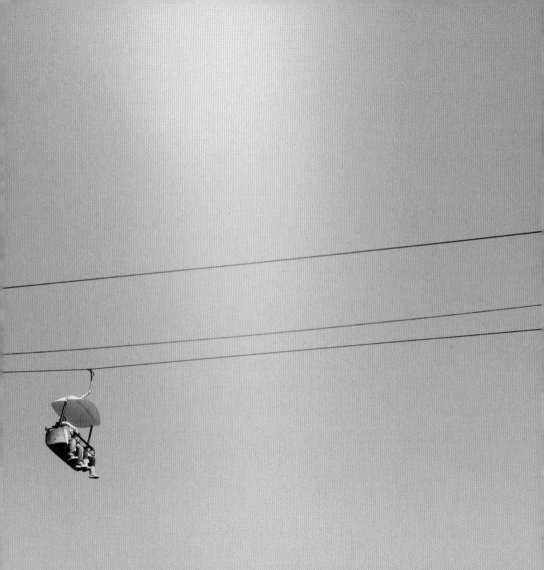

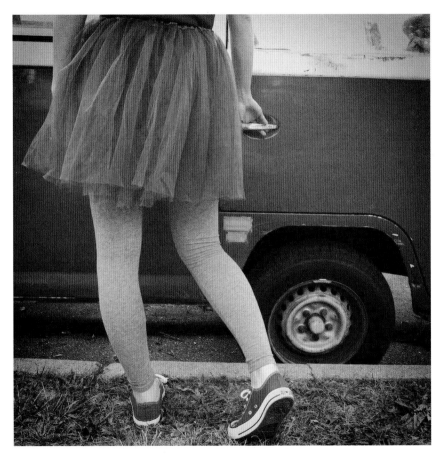

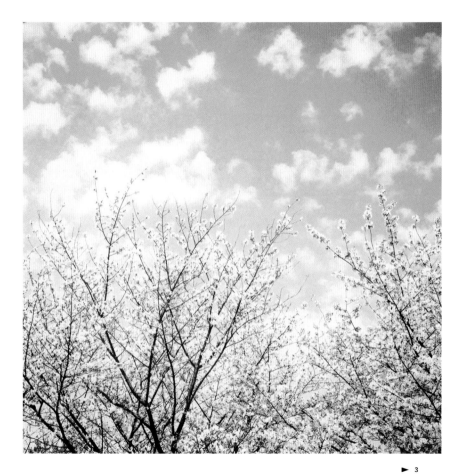

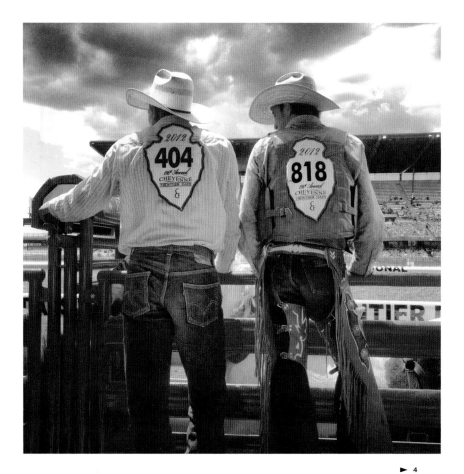

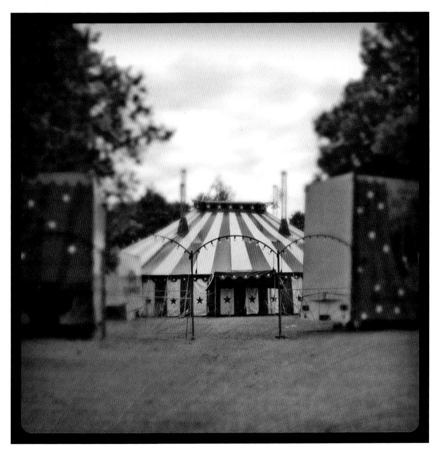

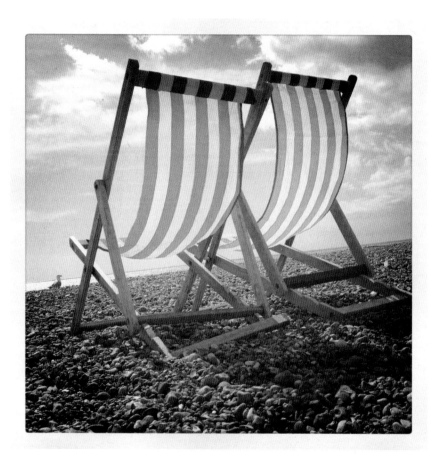

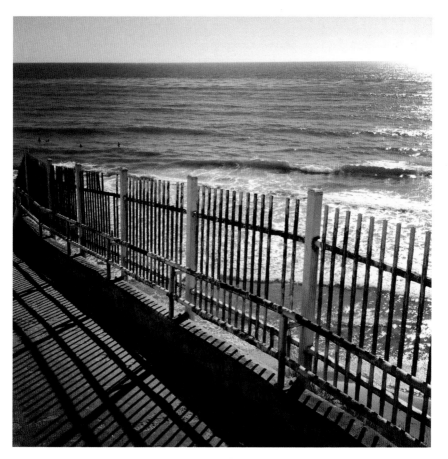

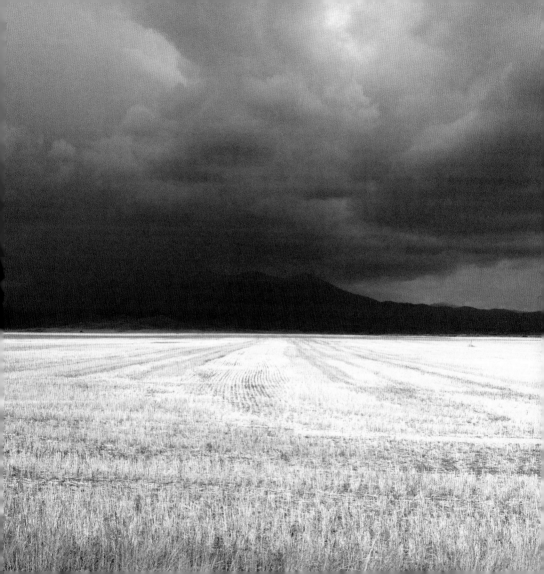

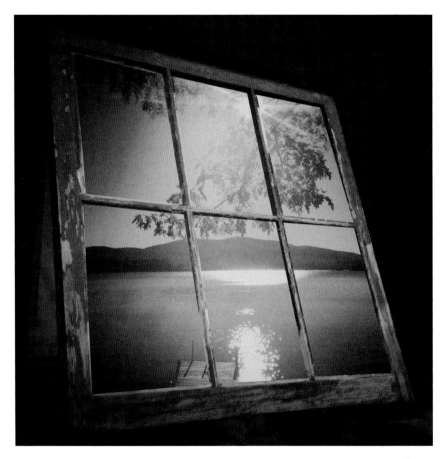

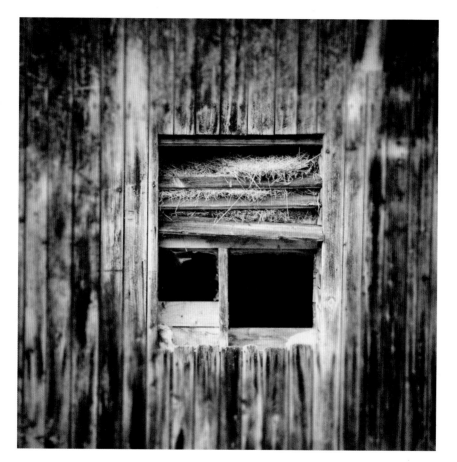

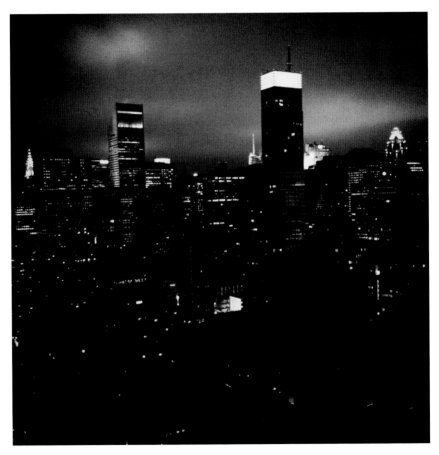

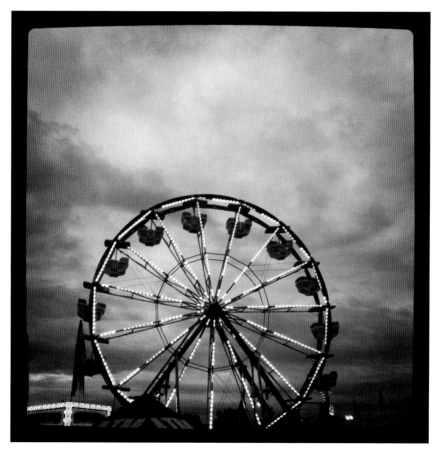

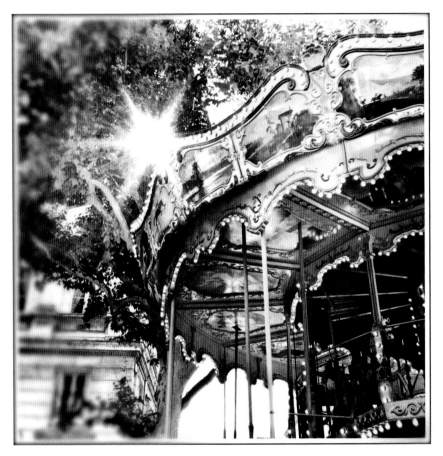

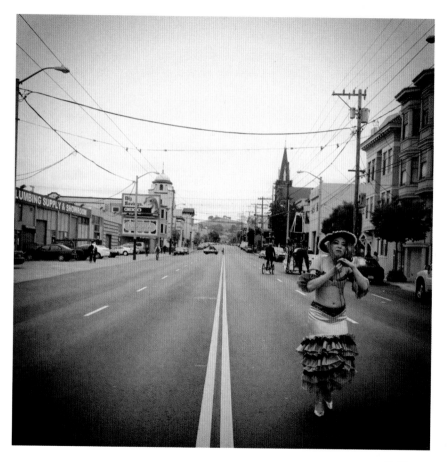

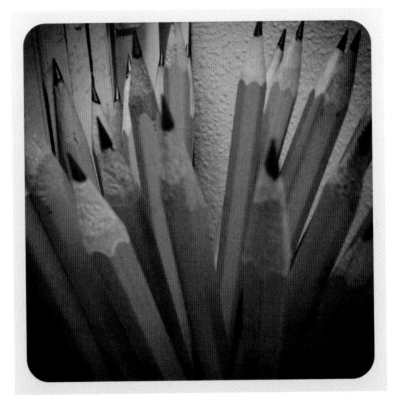

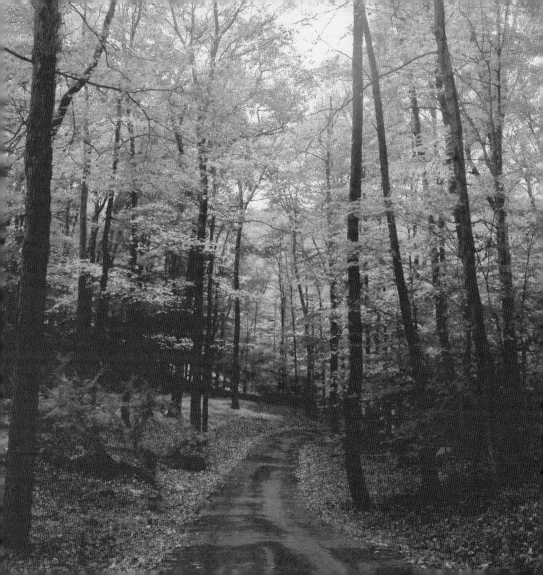

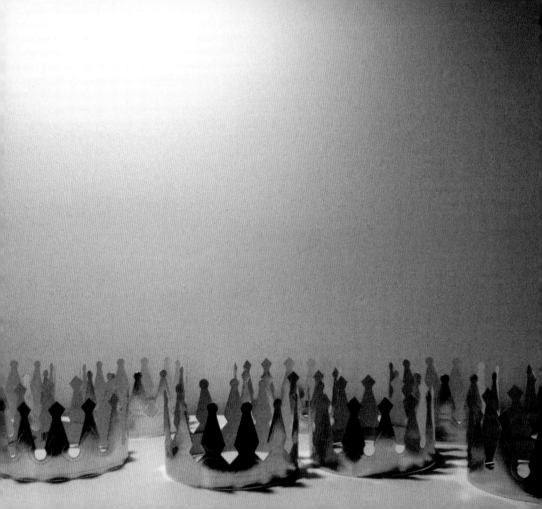

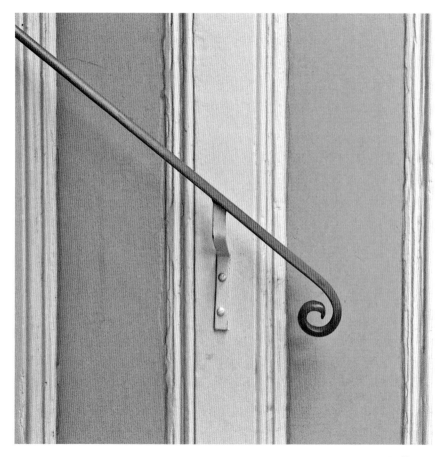

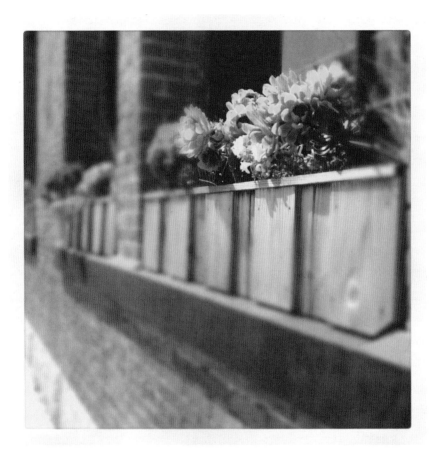

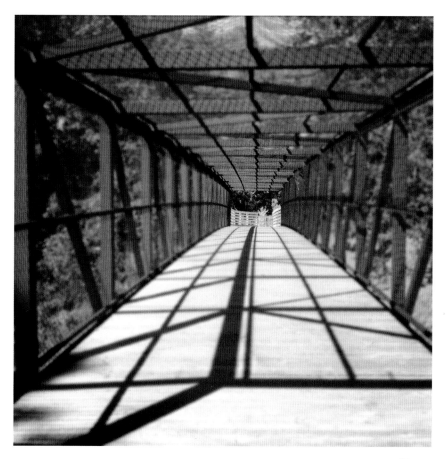

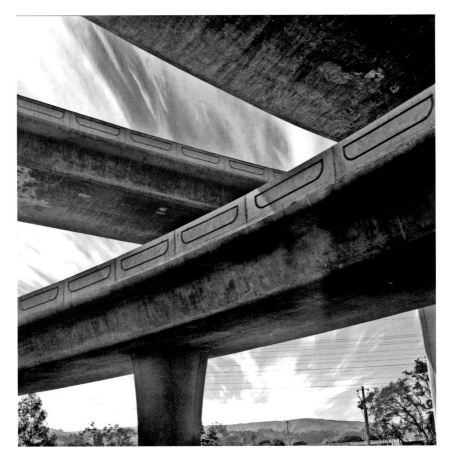

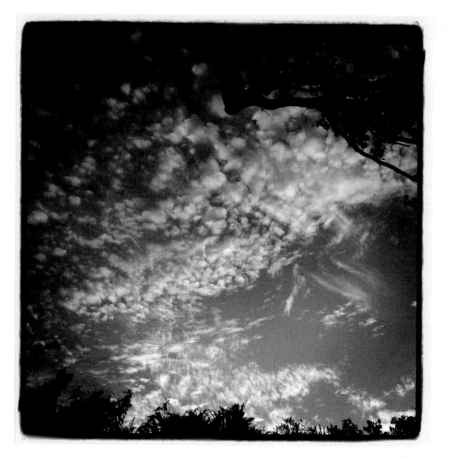

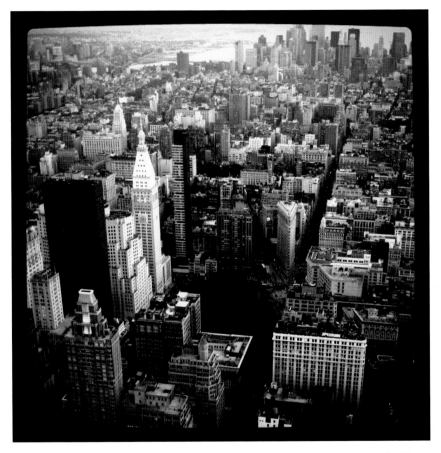

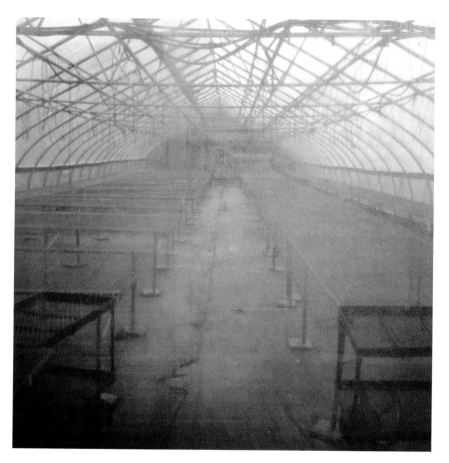

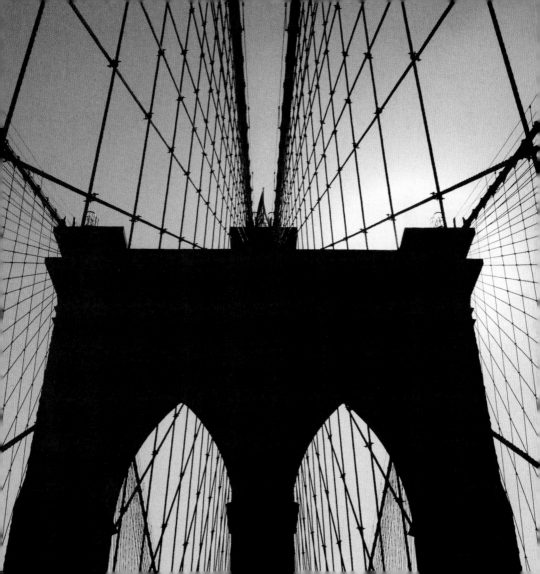

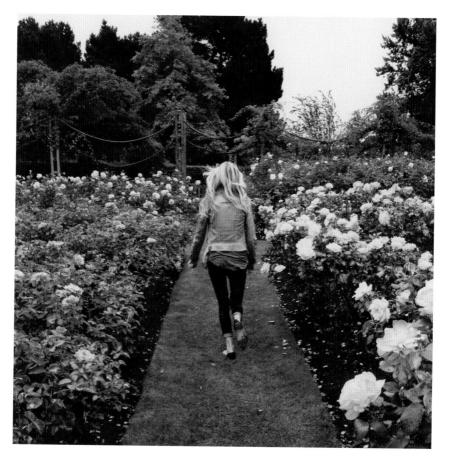

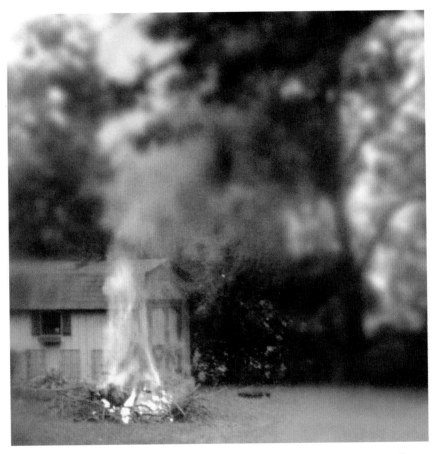

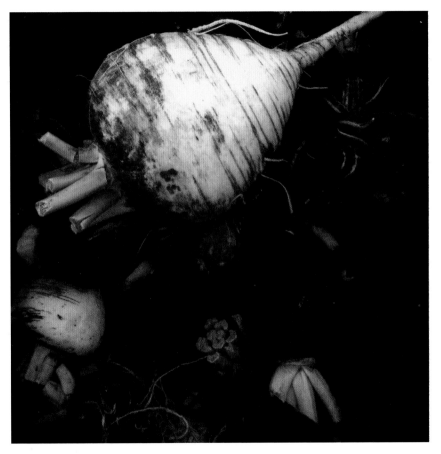

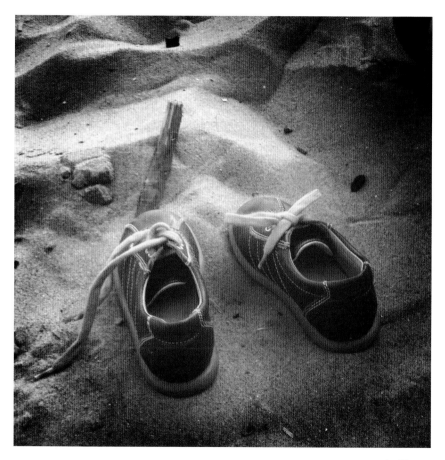

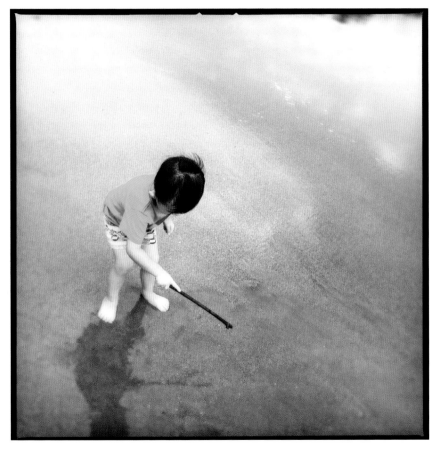

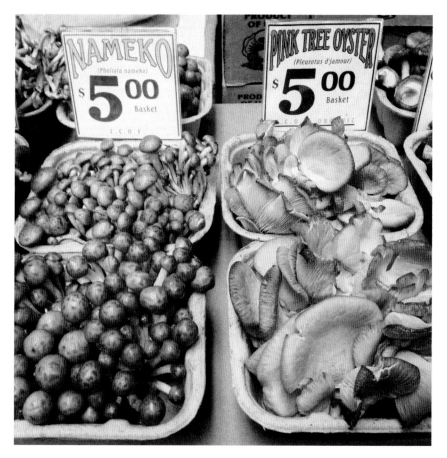

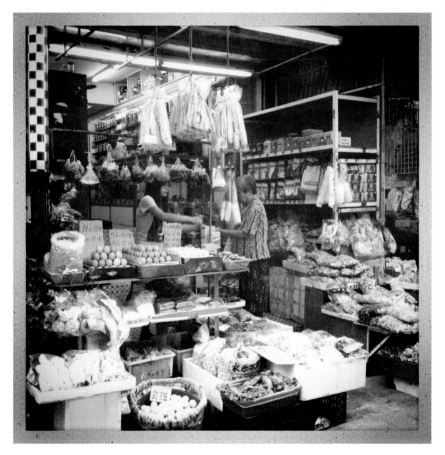

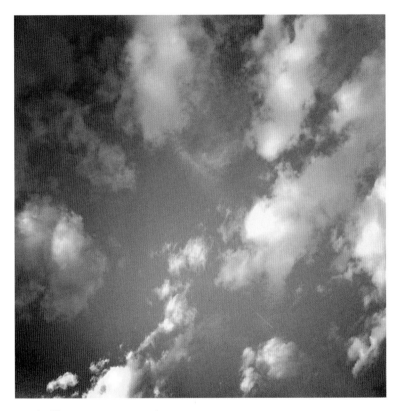

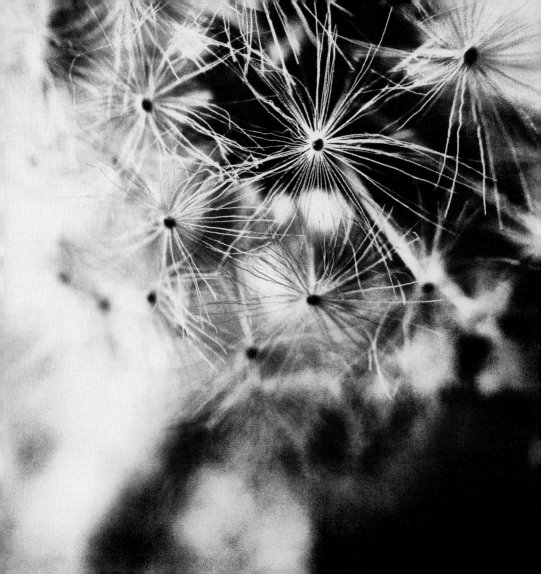

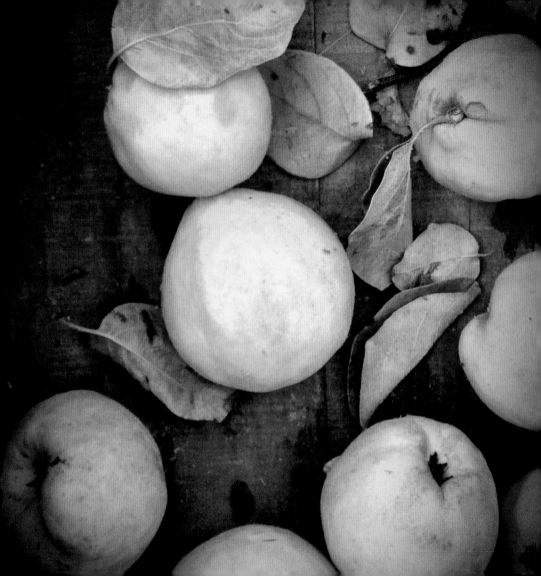

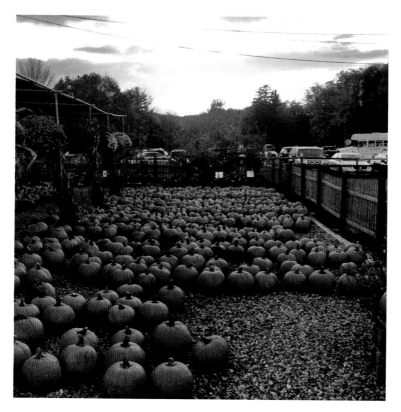

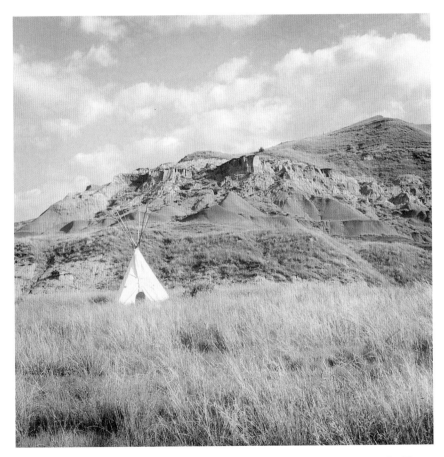

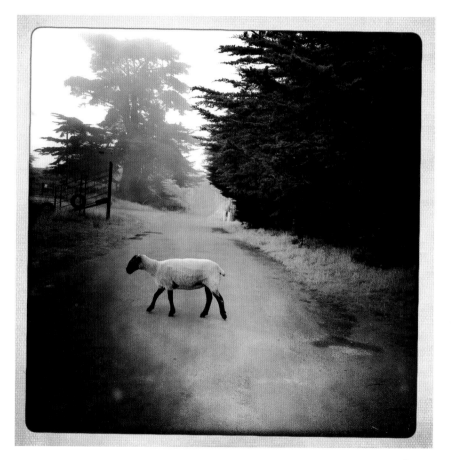

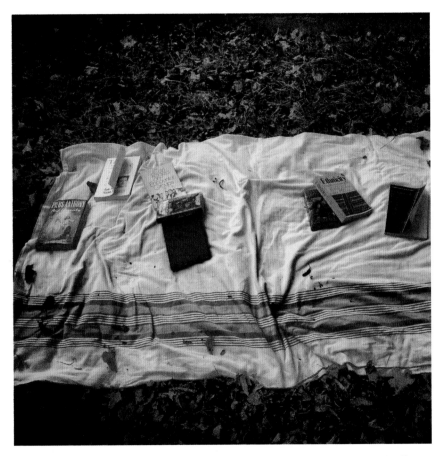

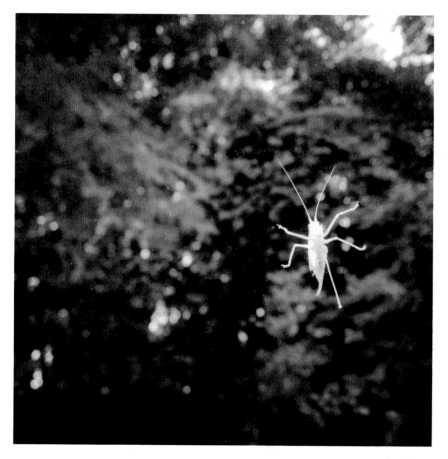

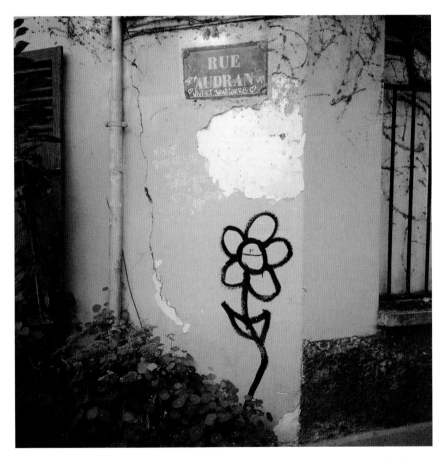

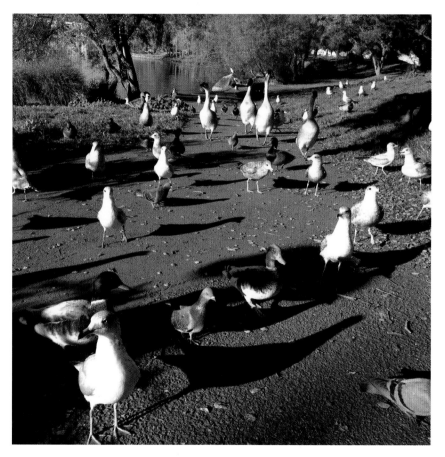

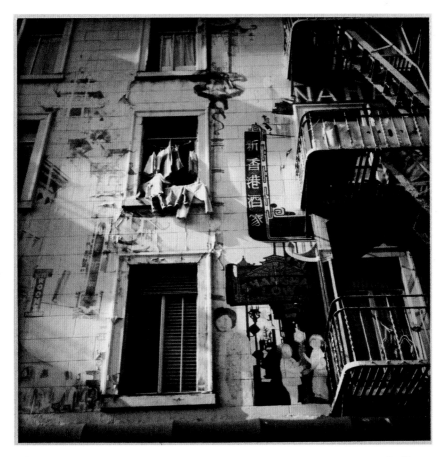

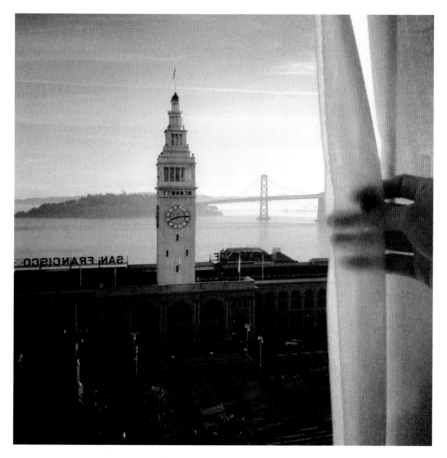

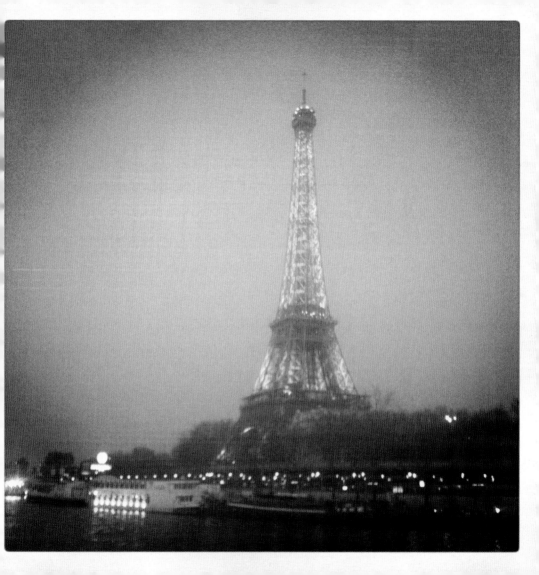

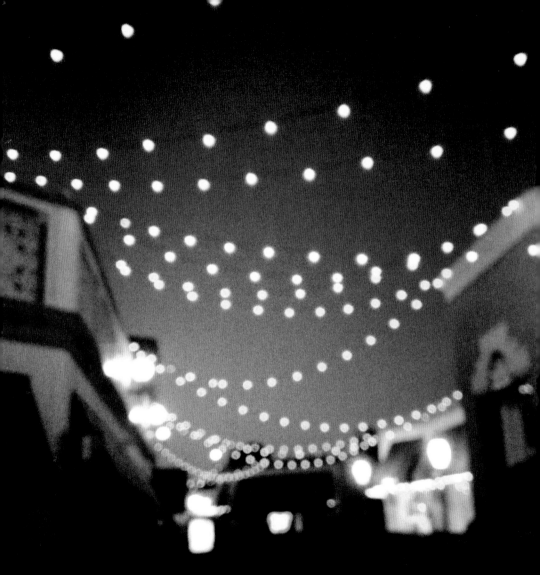

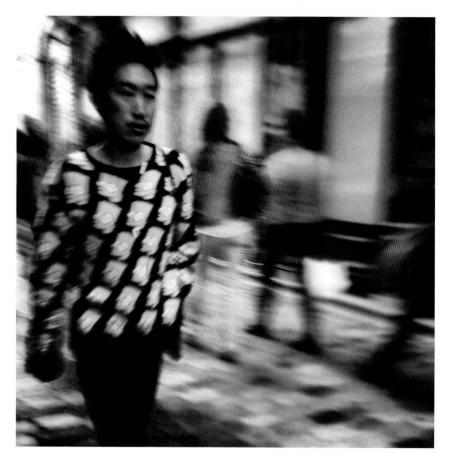

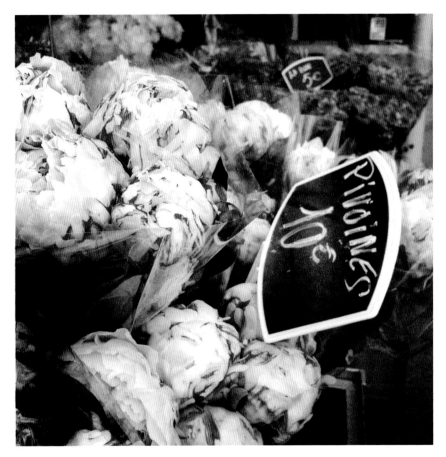

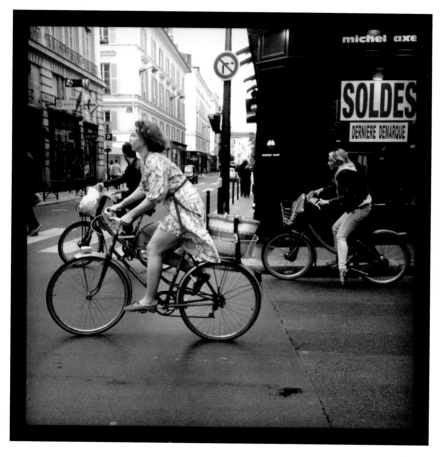

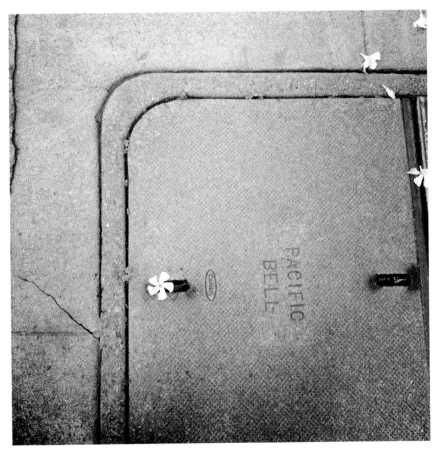

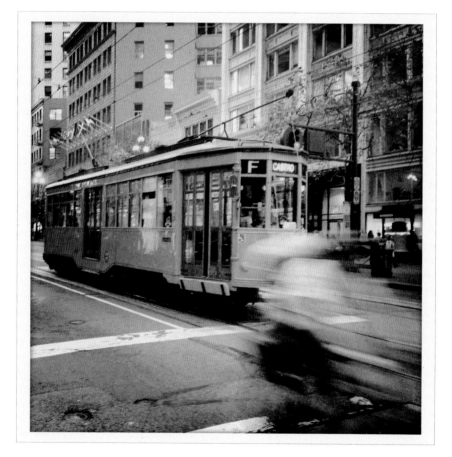

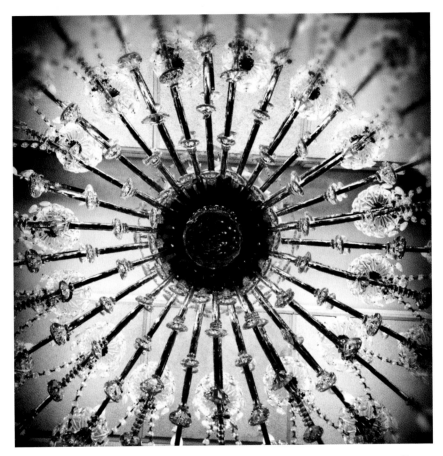

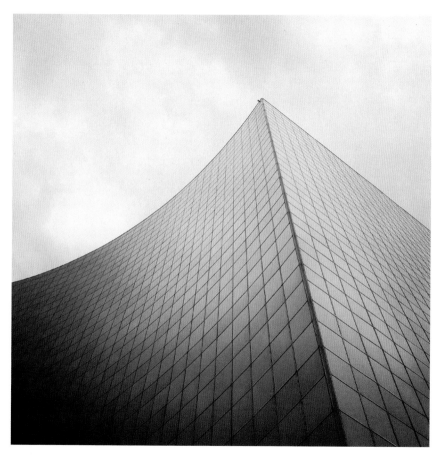

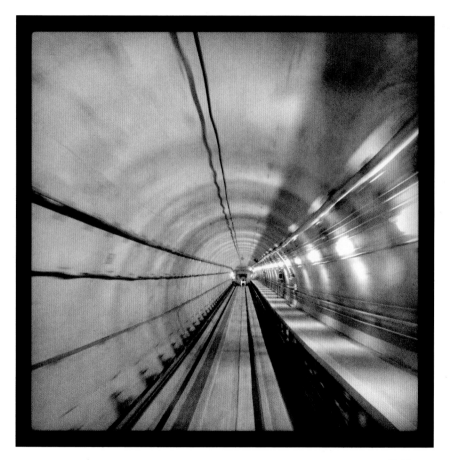

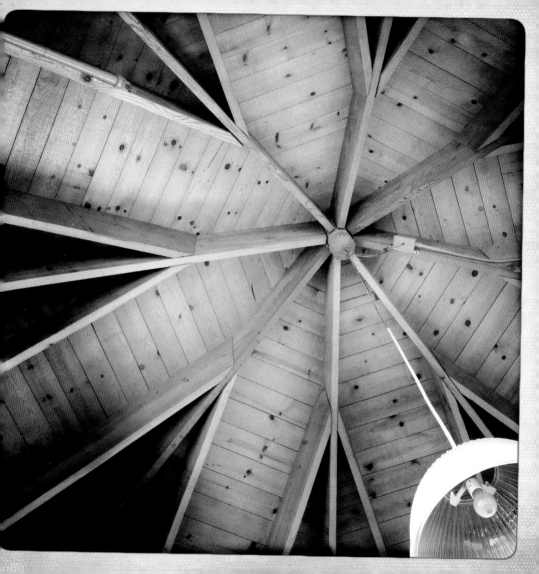

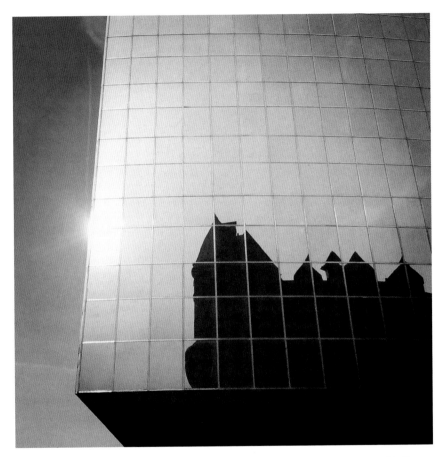

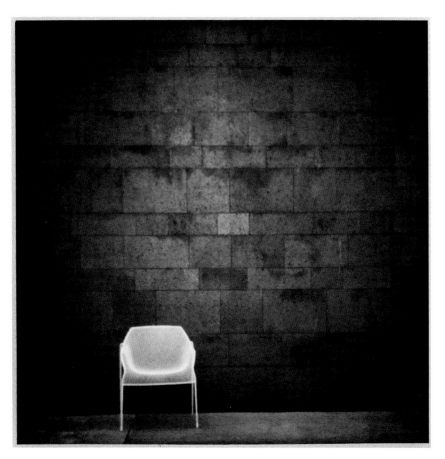

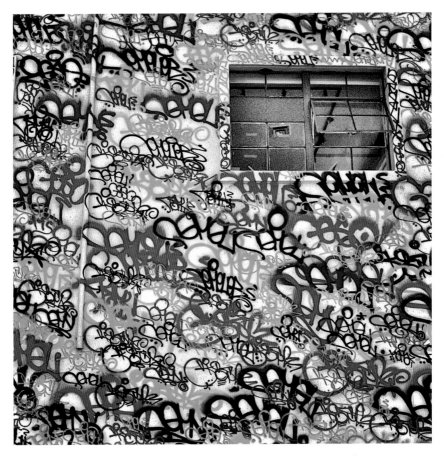

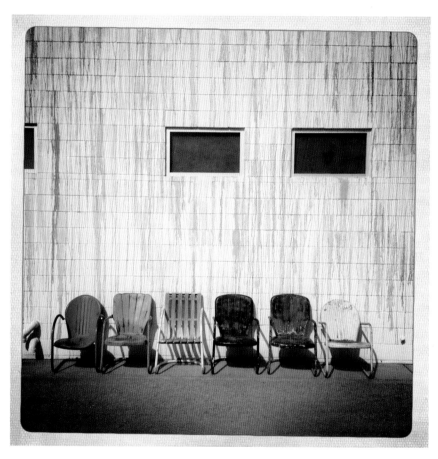

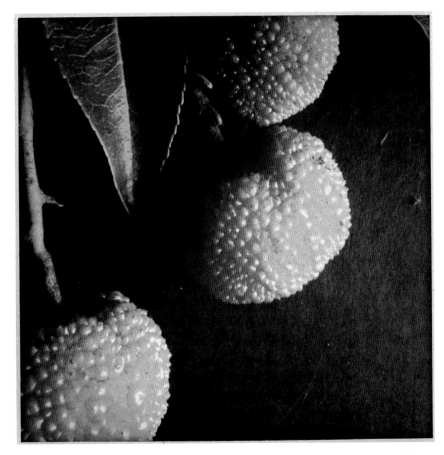

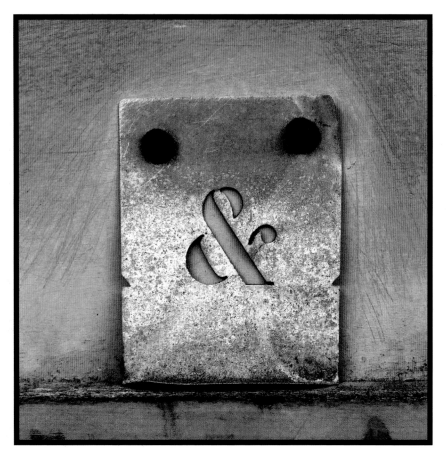

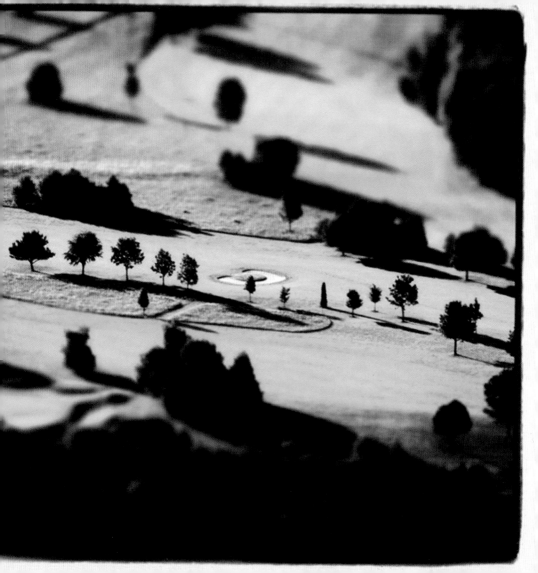

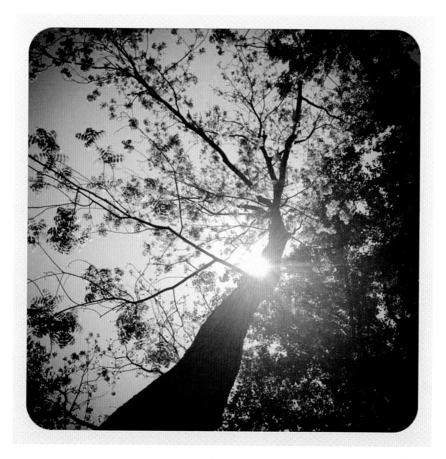

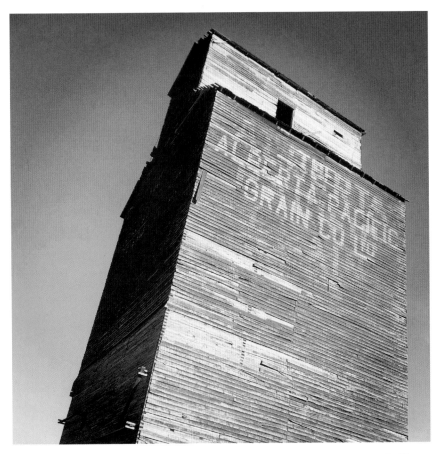

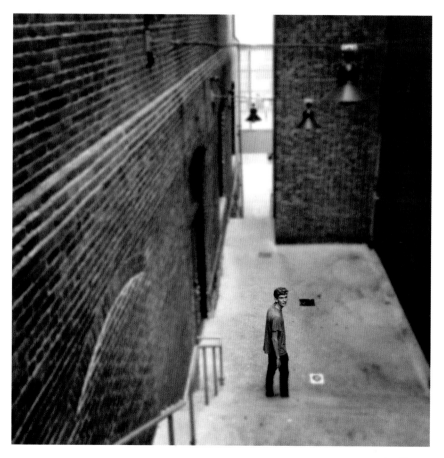

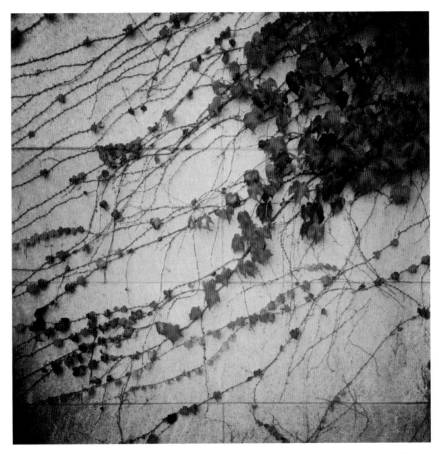

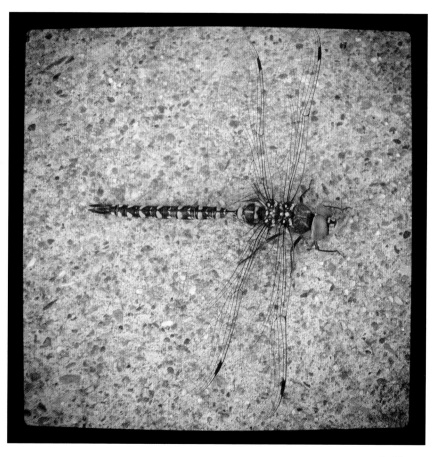

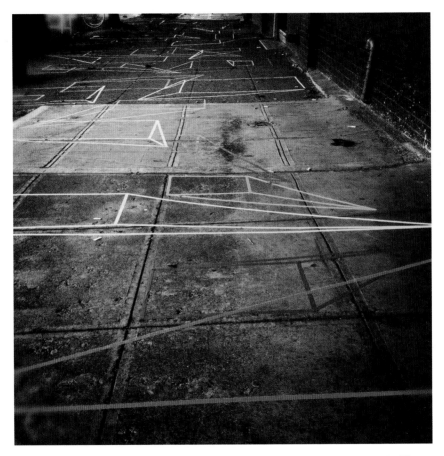

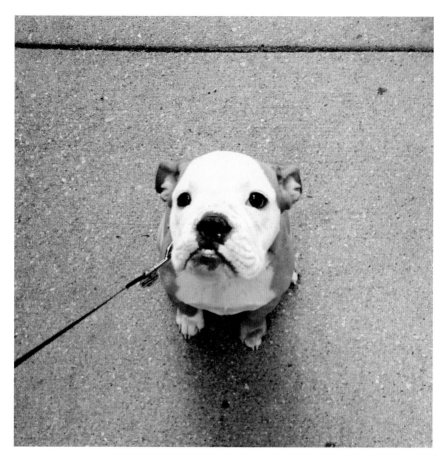

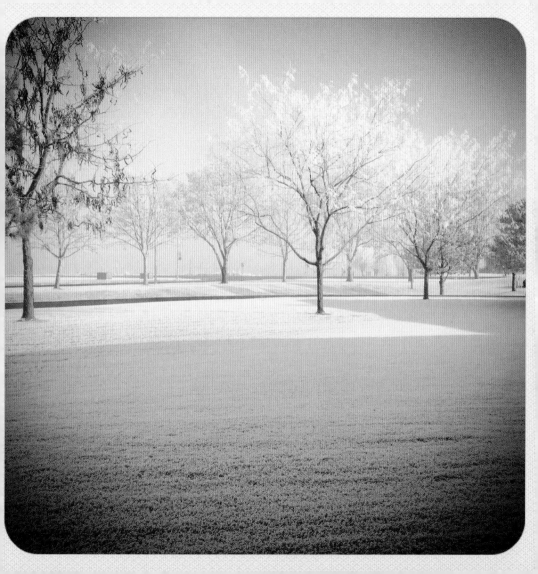

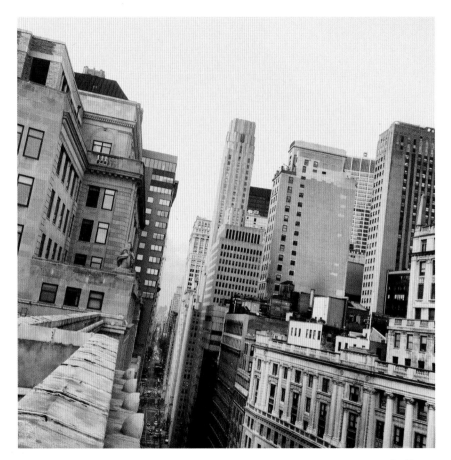

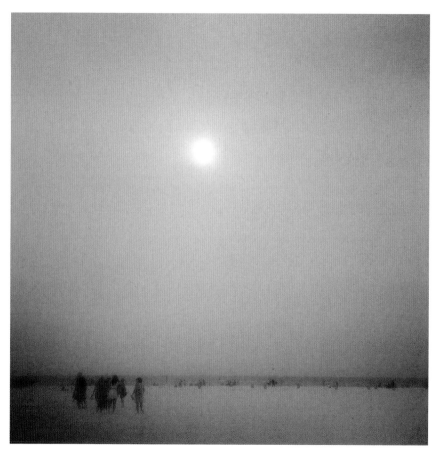

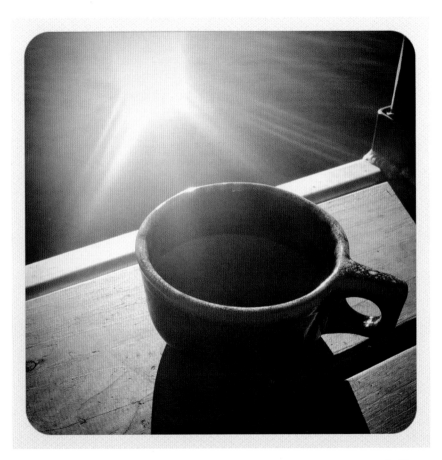

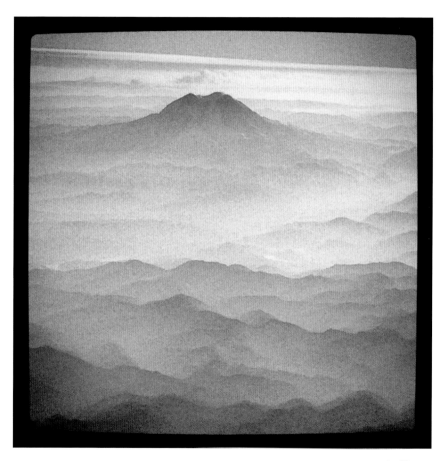

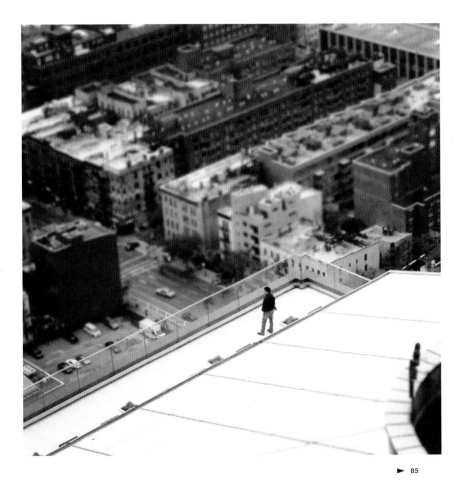

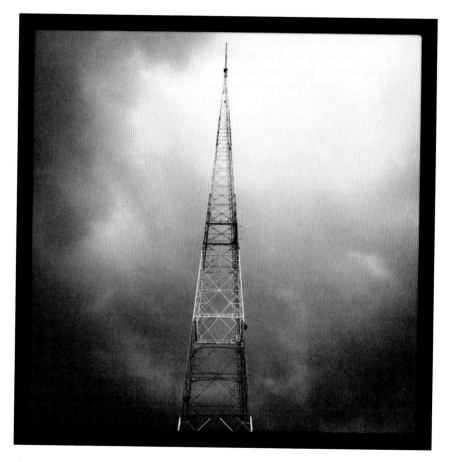

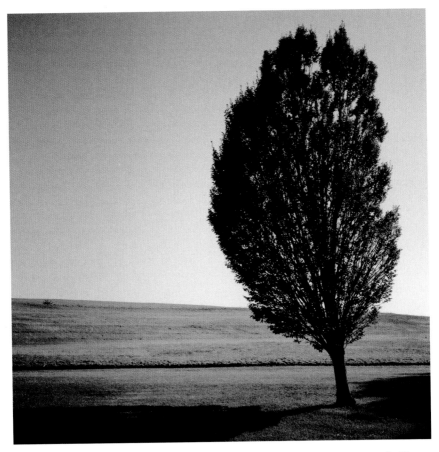

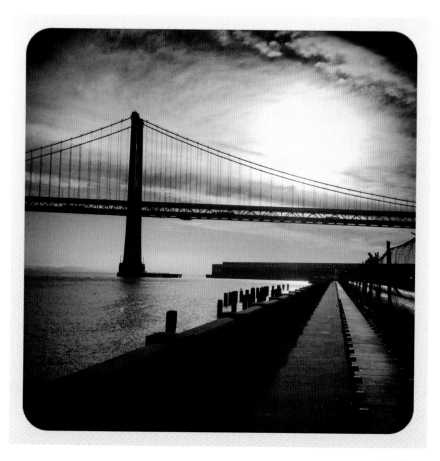

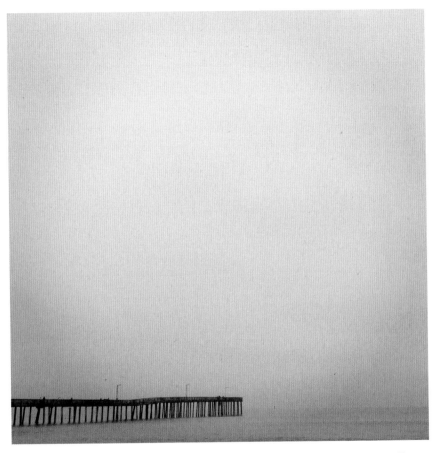

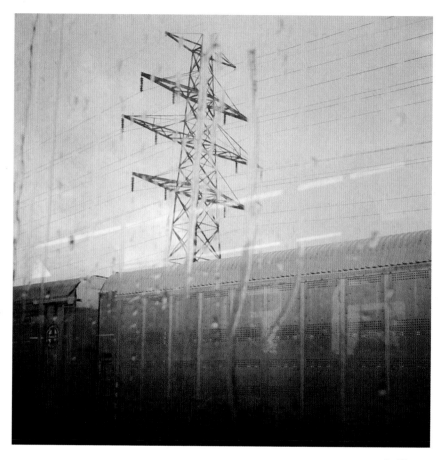

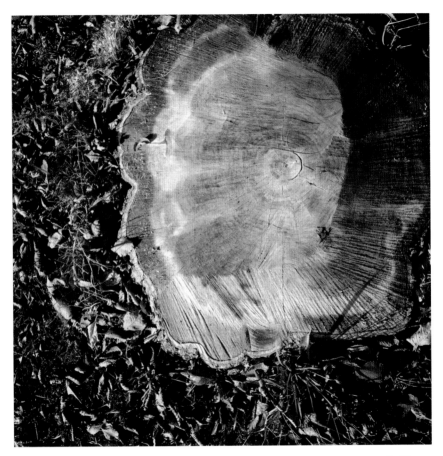

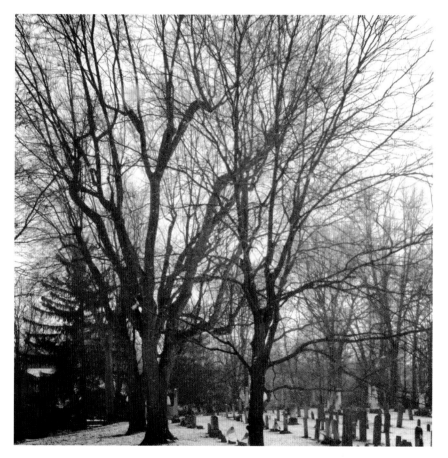

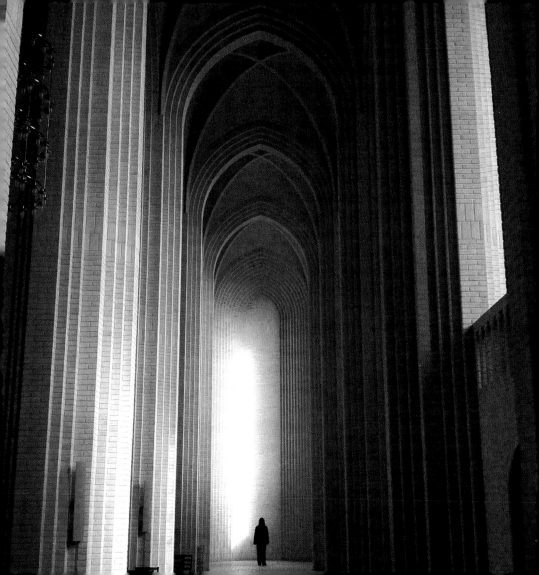

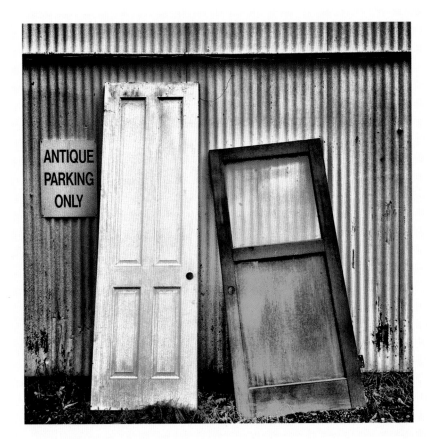

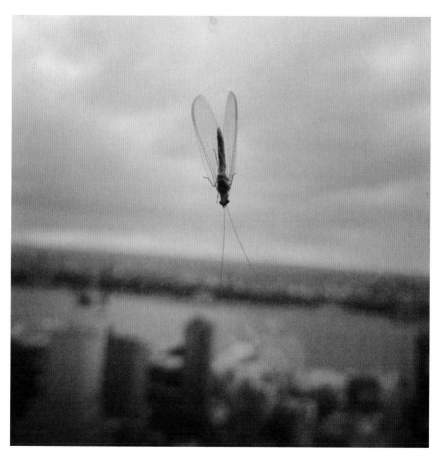

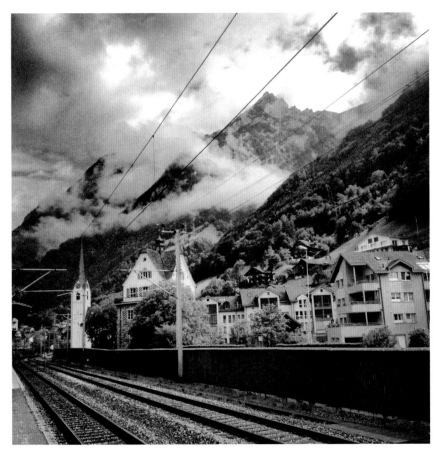

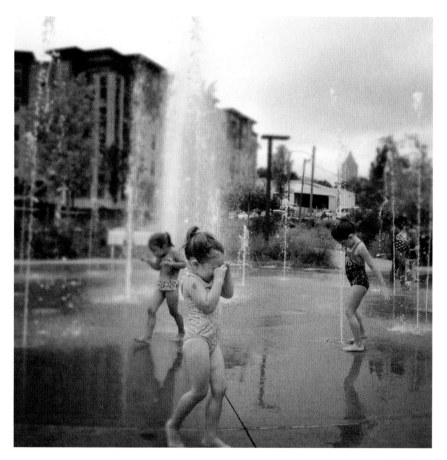

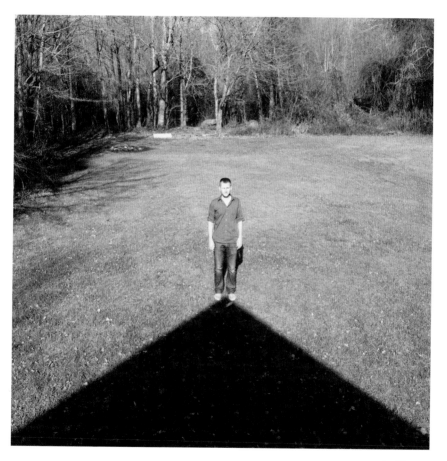

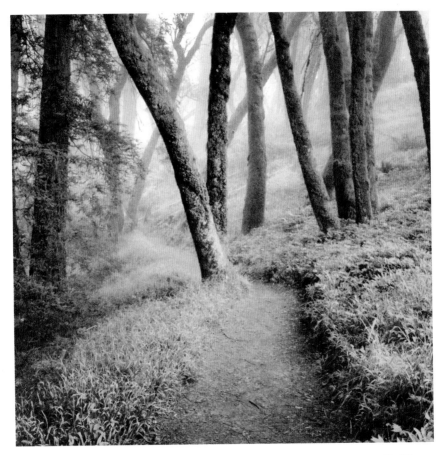

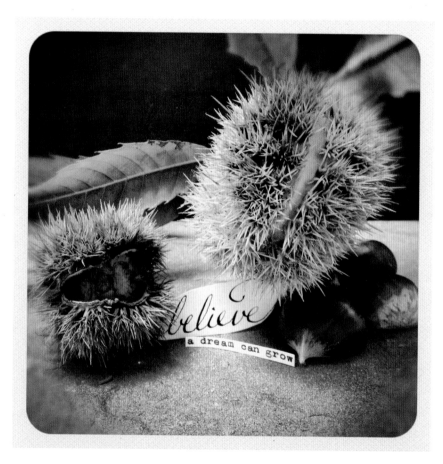

believe

a dream can grow

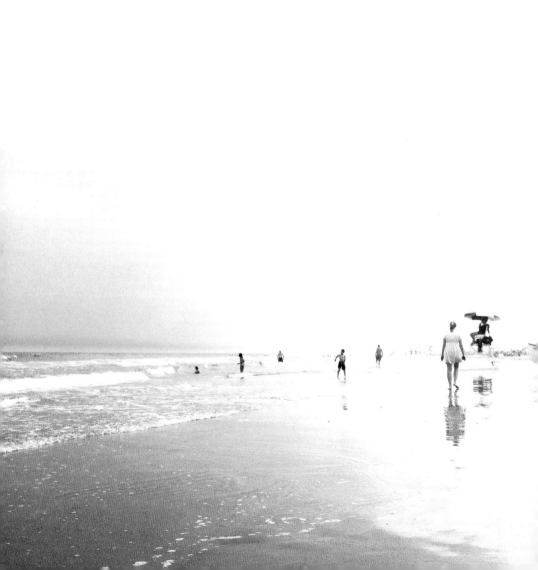

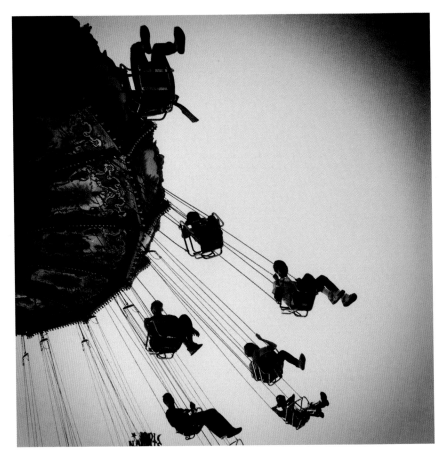

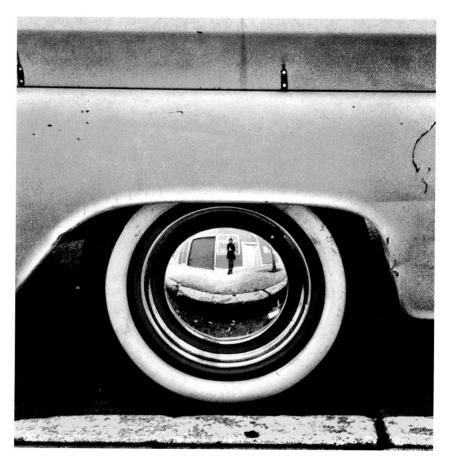

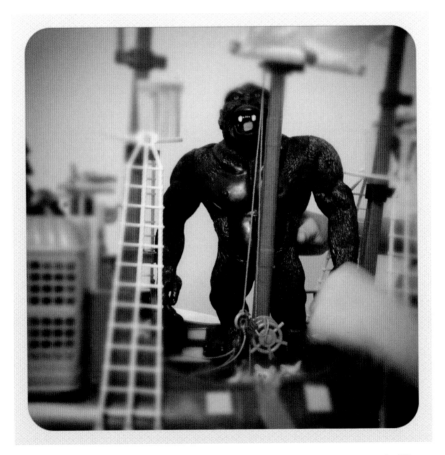

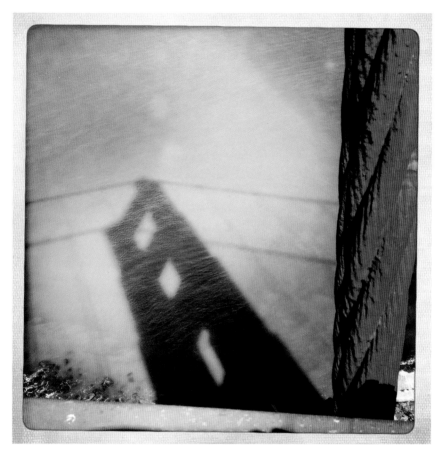

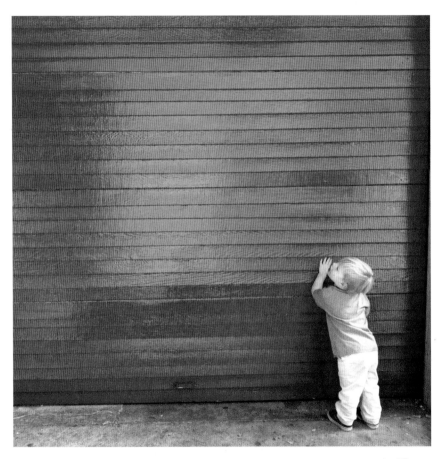

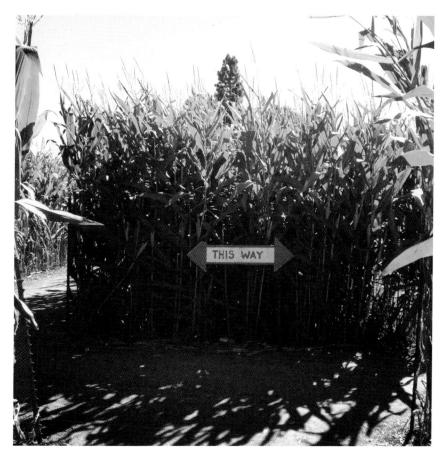

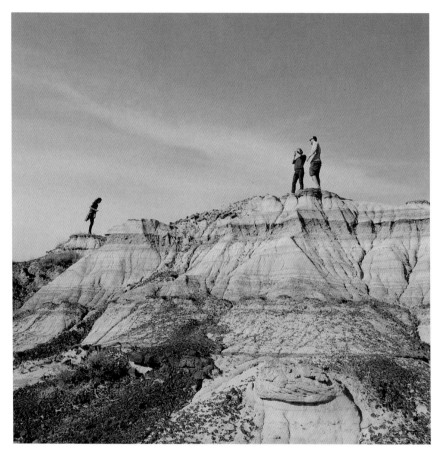

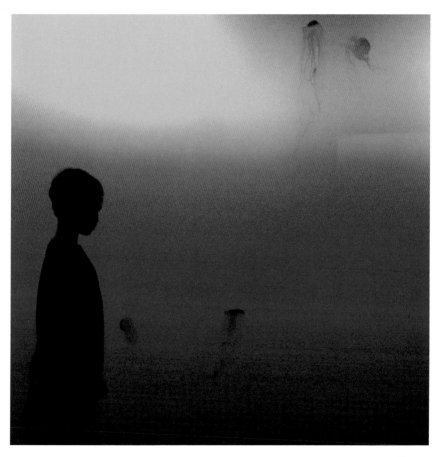

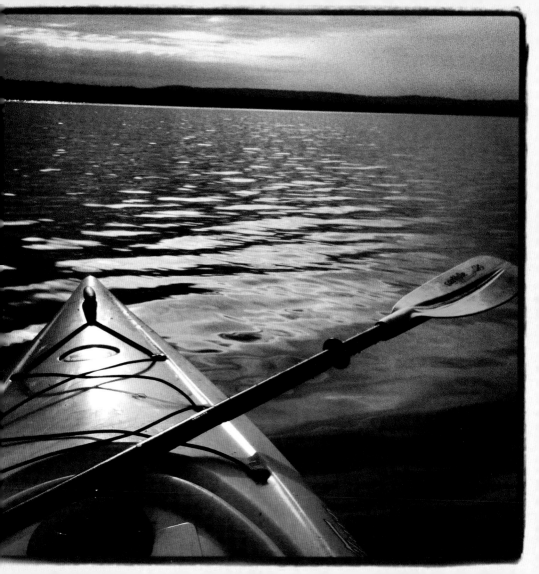

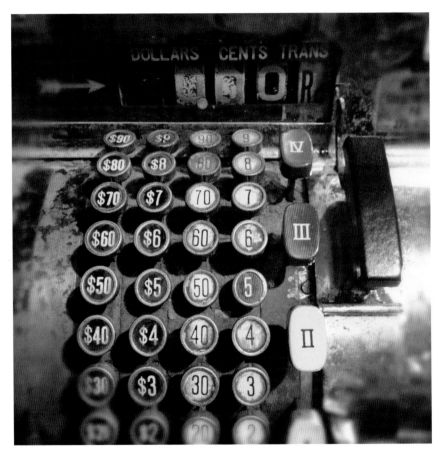

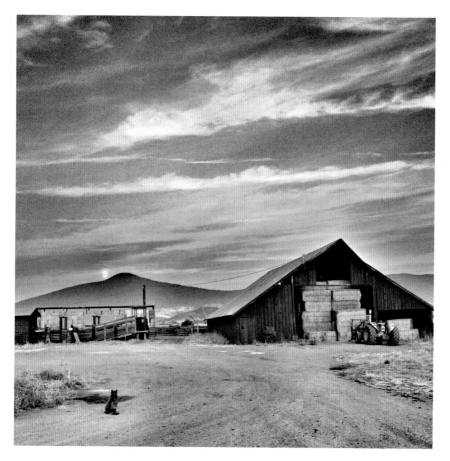

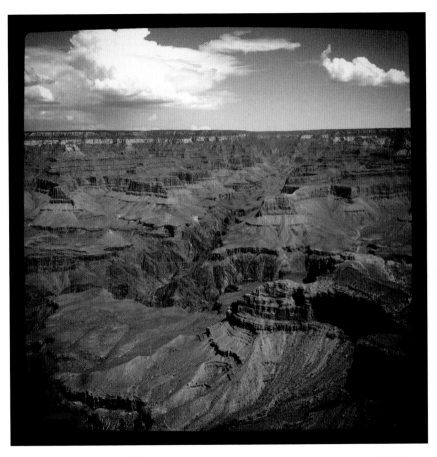

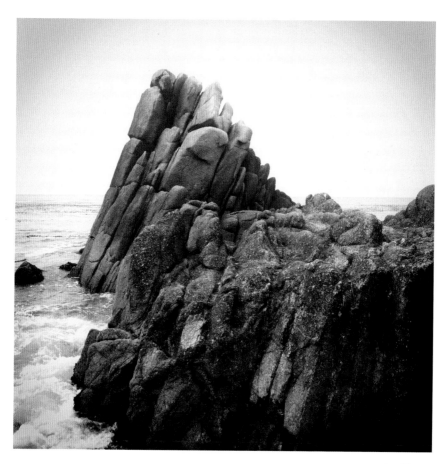

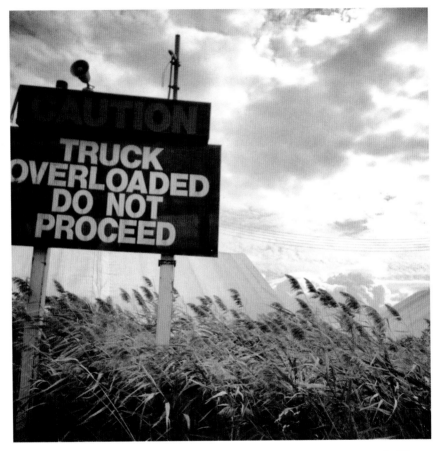

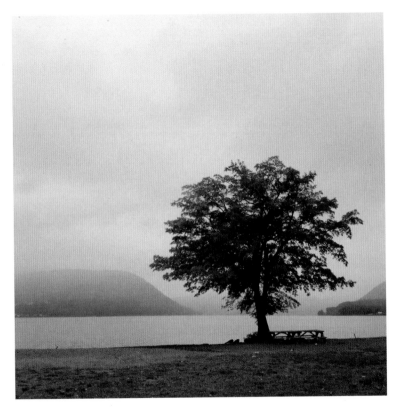

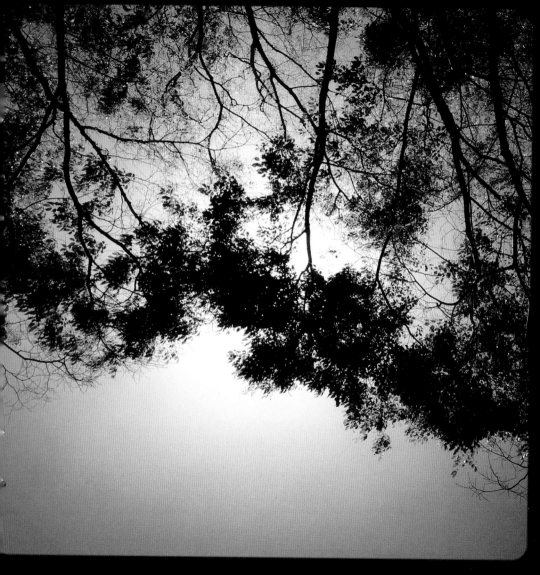

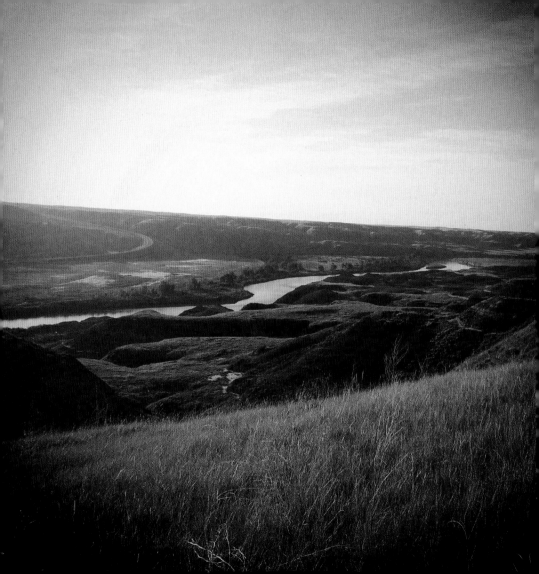

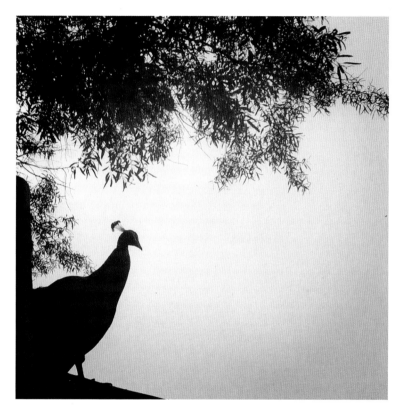

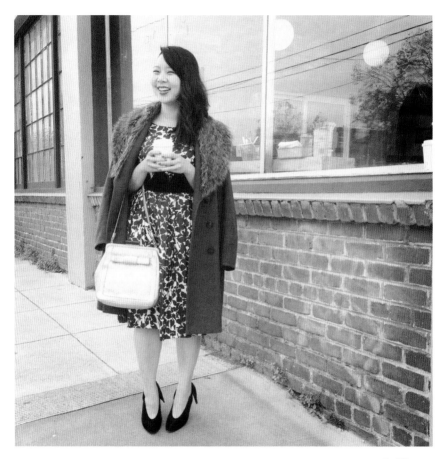

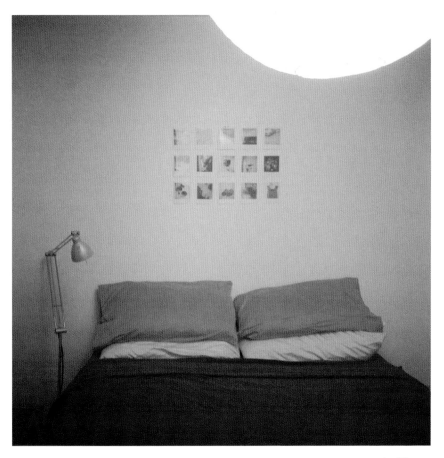

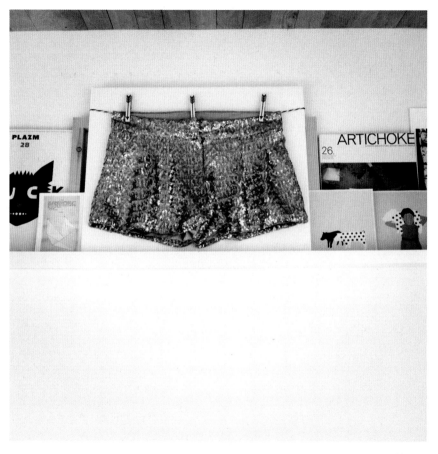

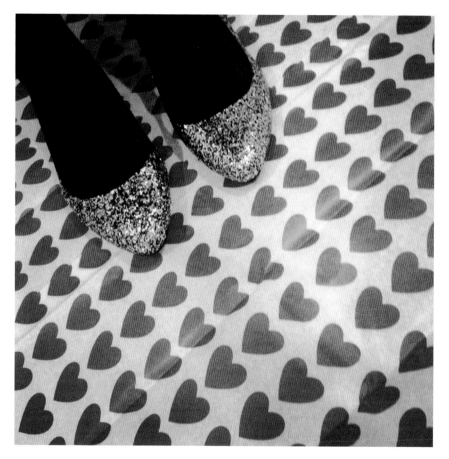

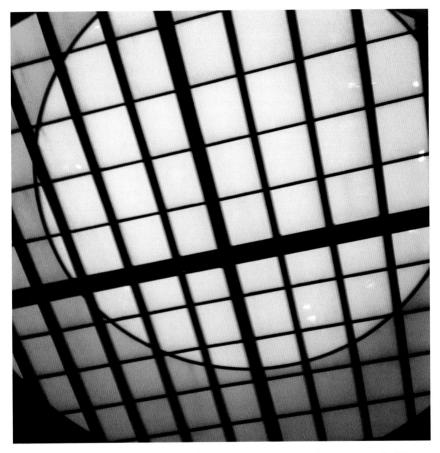

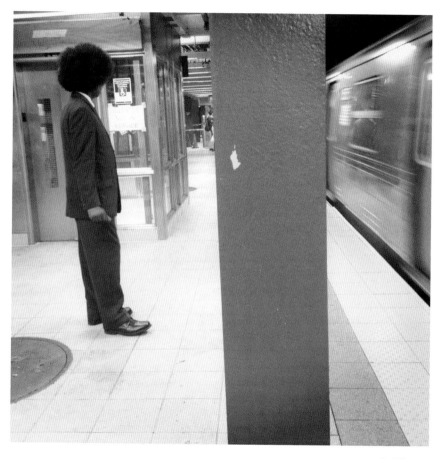

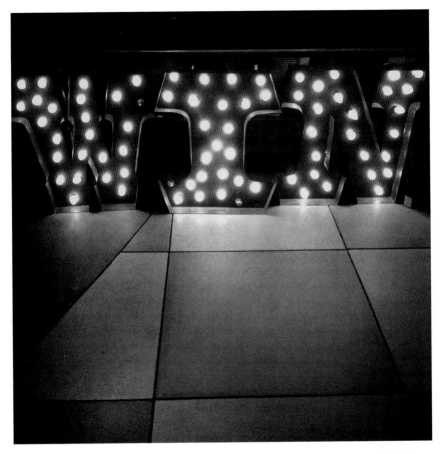

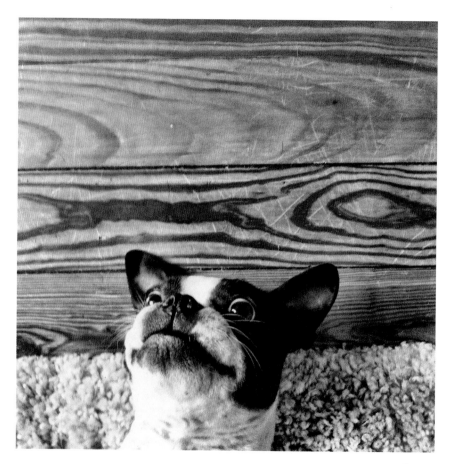

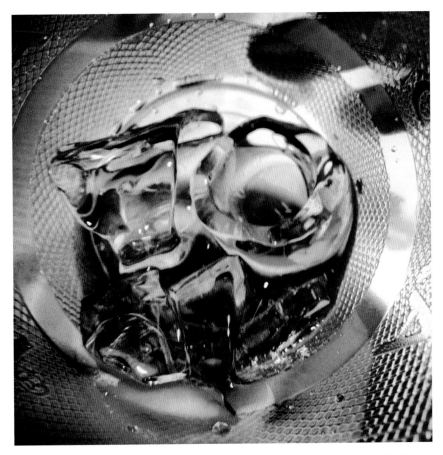

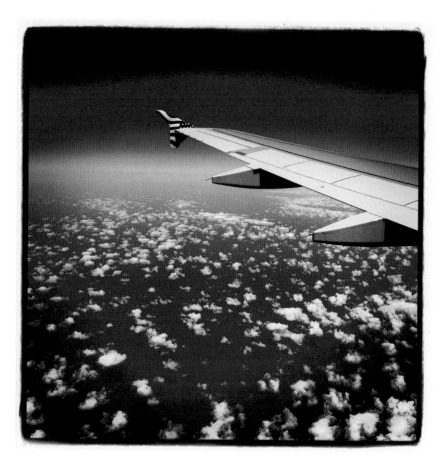

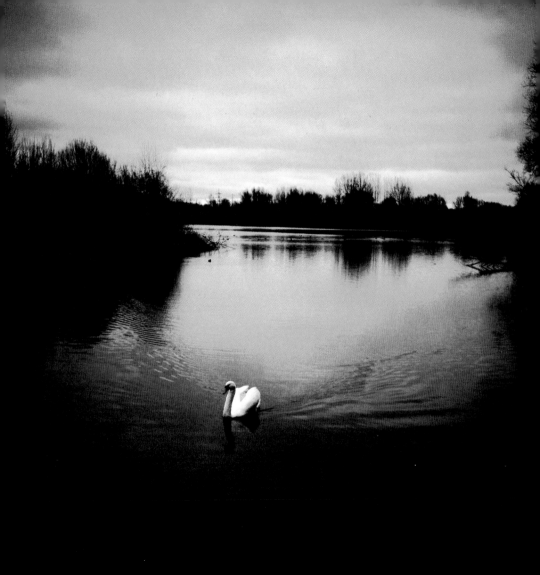

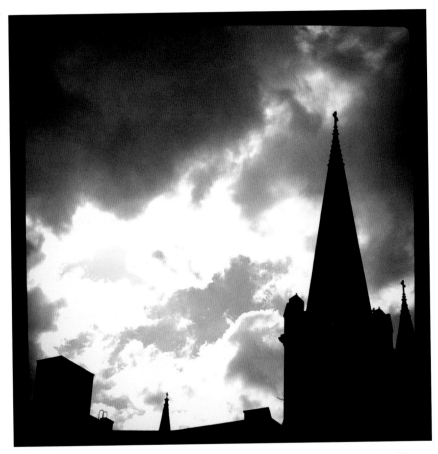

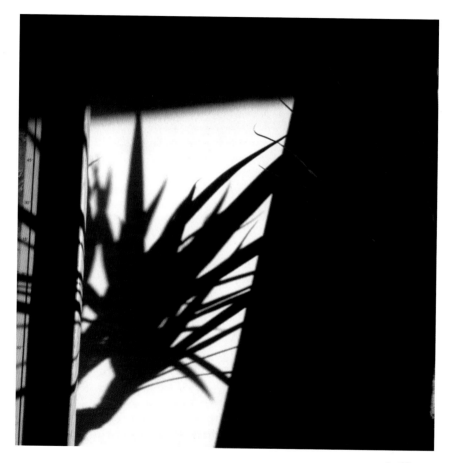

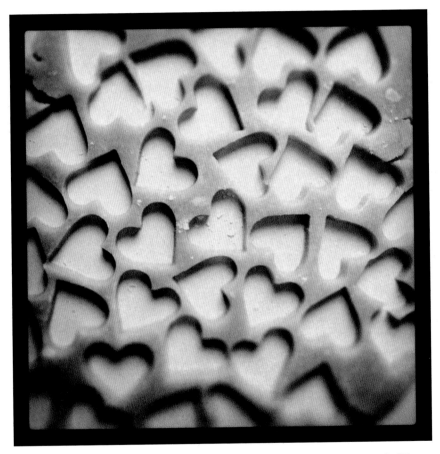

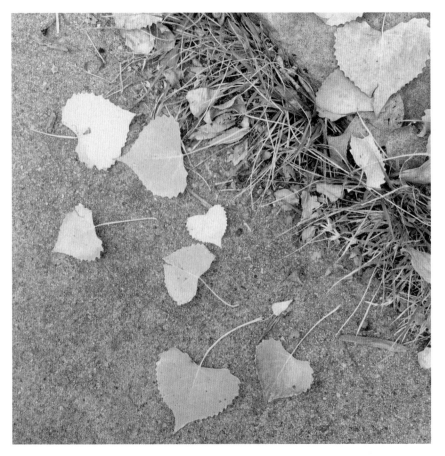

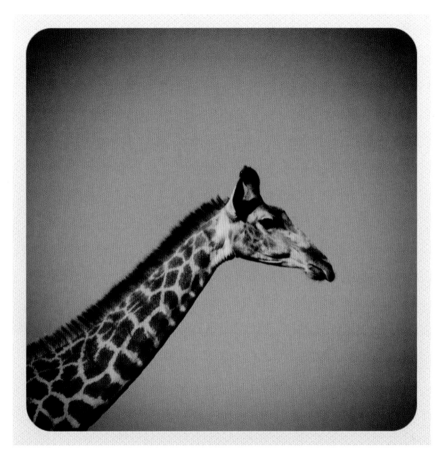

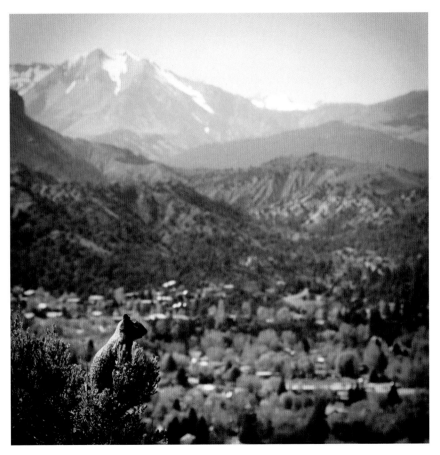

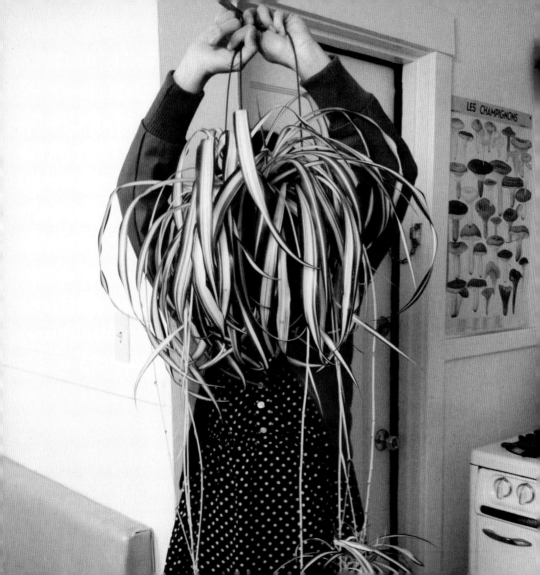

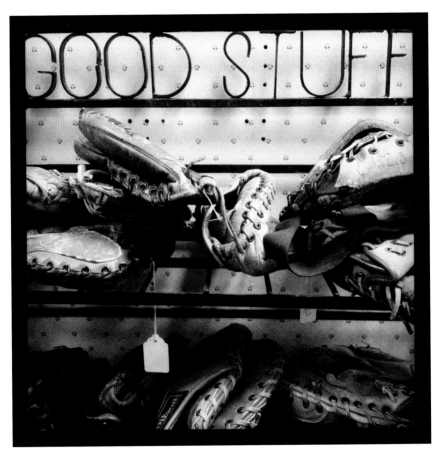

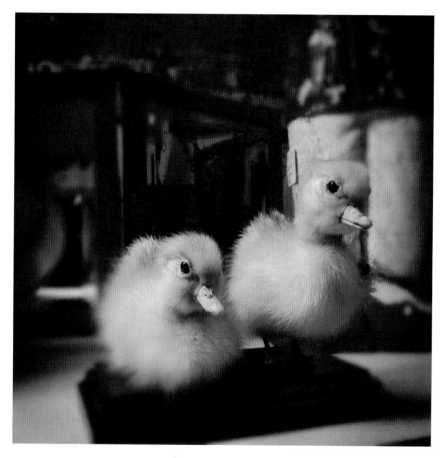

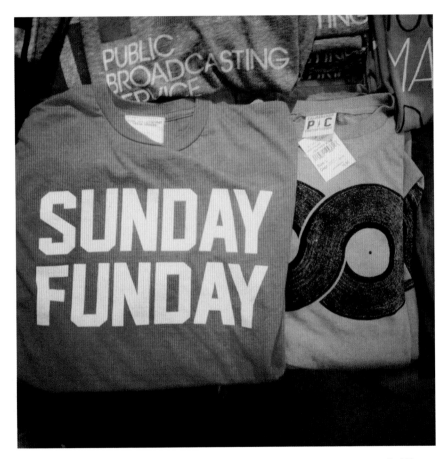

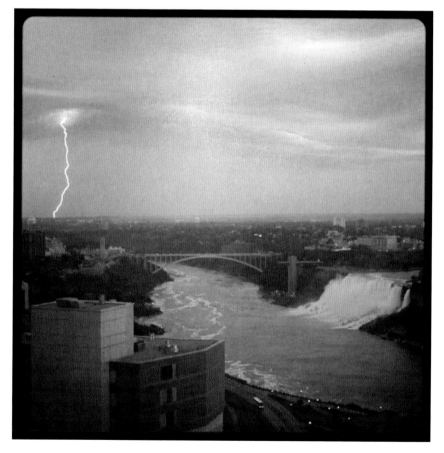

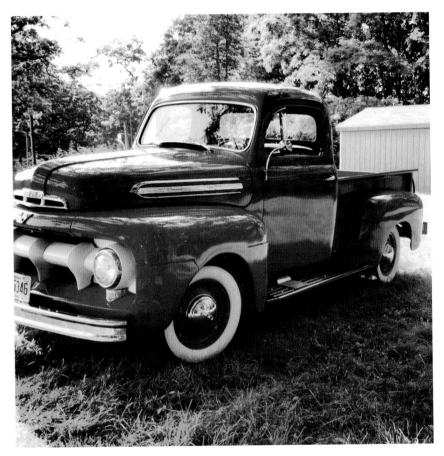

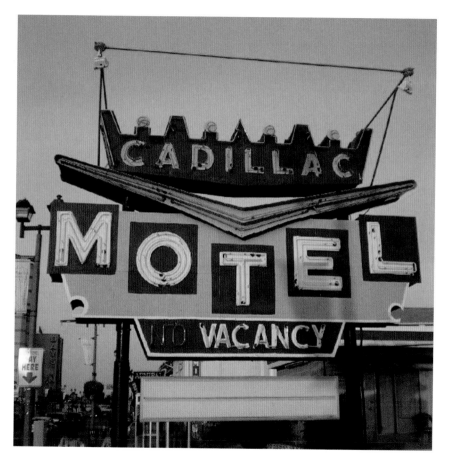

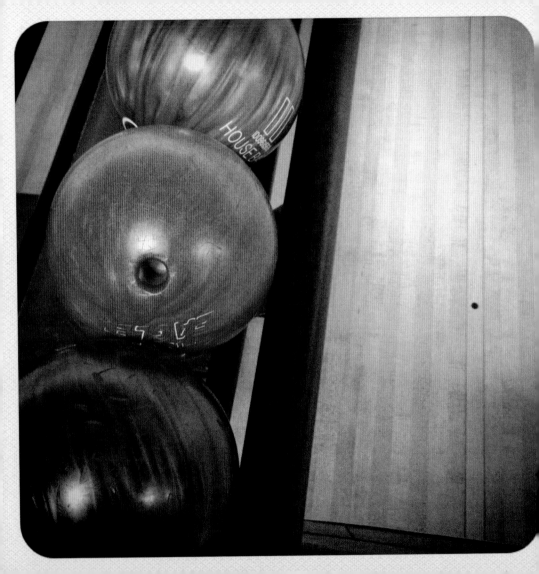

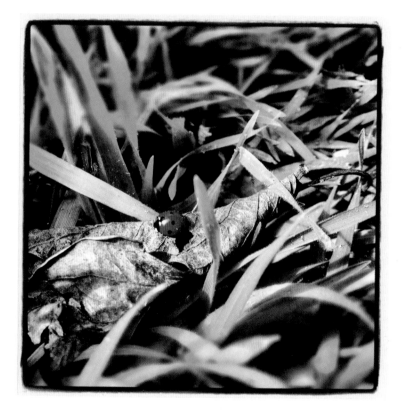

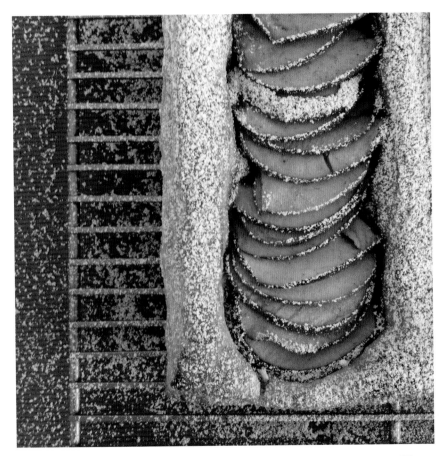

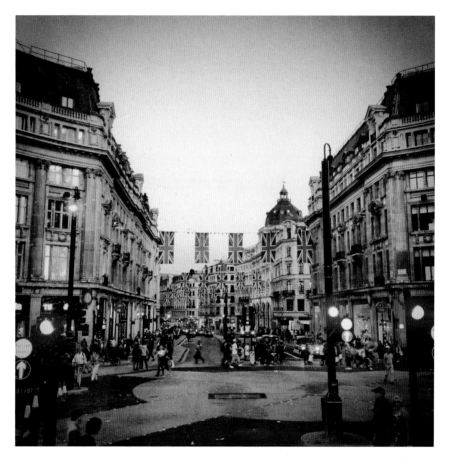

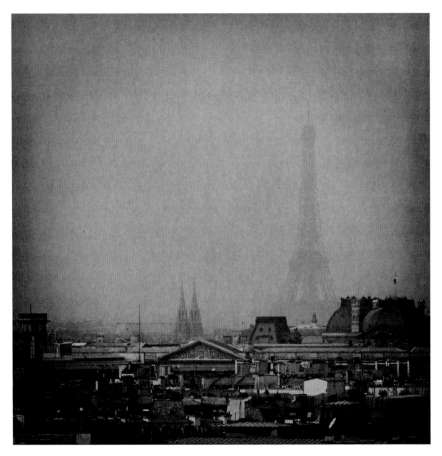

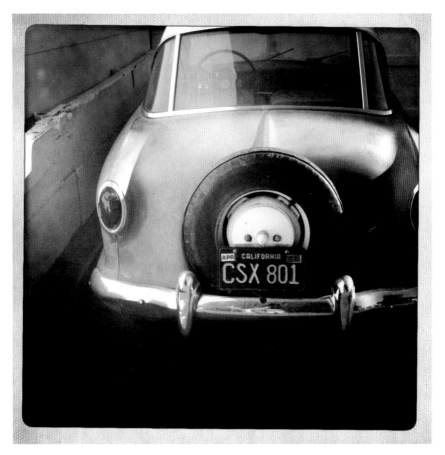

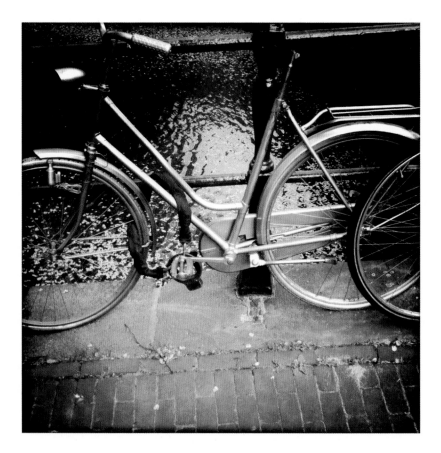

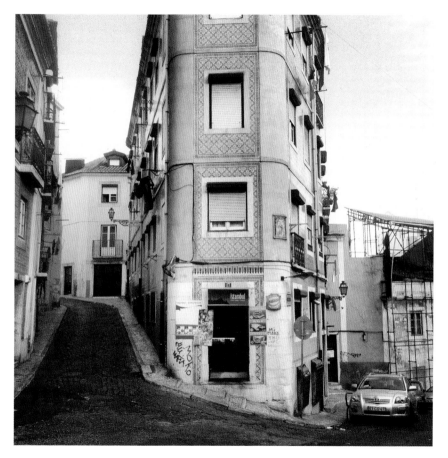

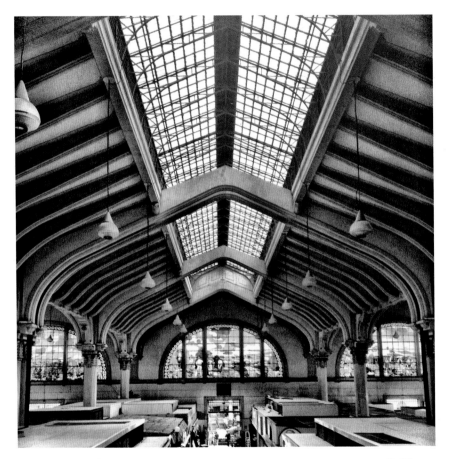

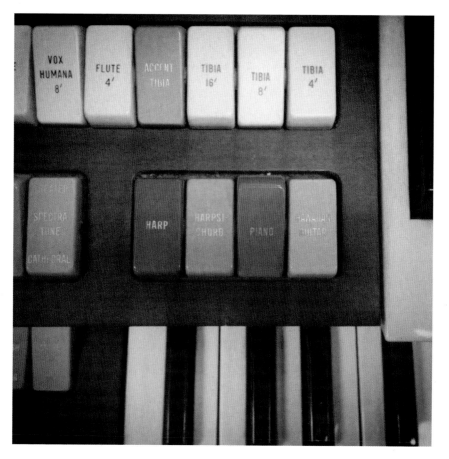

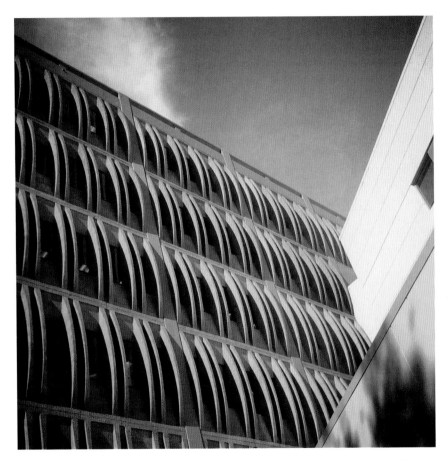

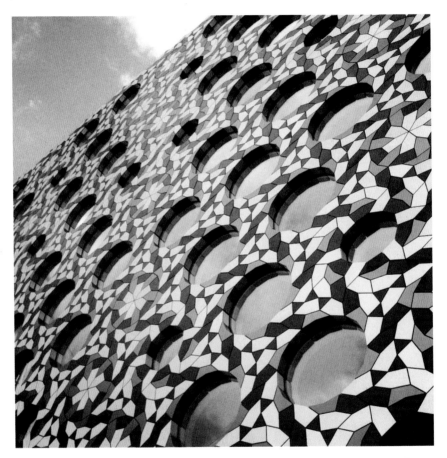

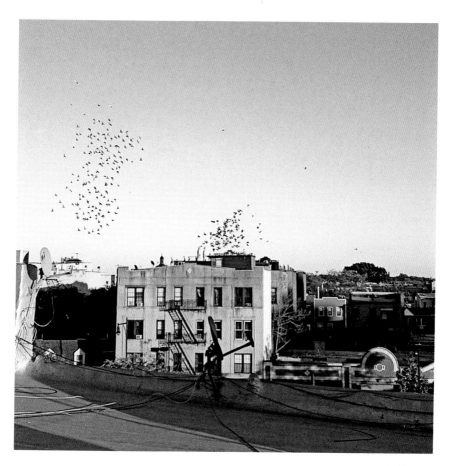

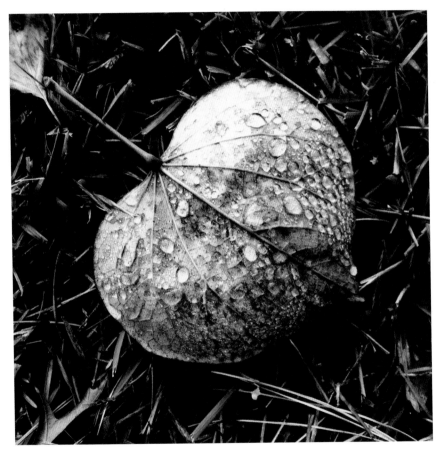

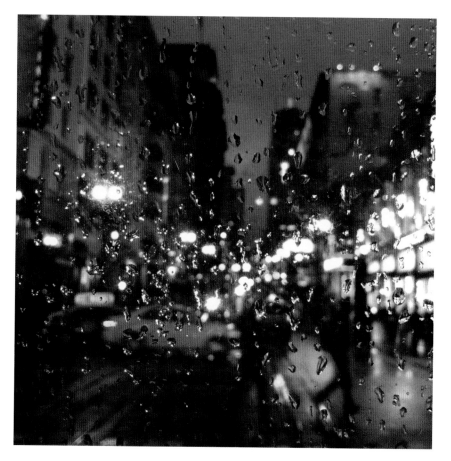

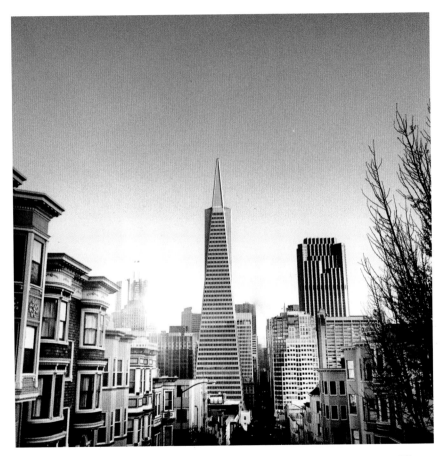

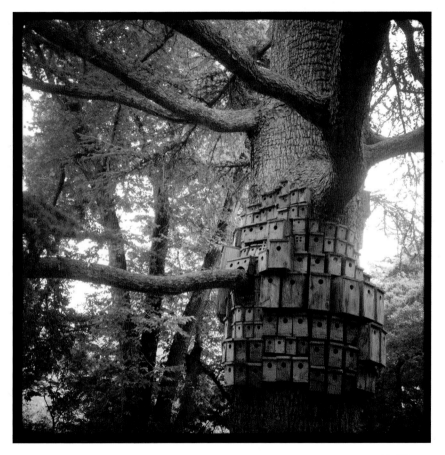

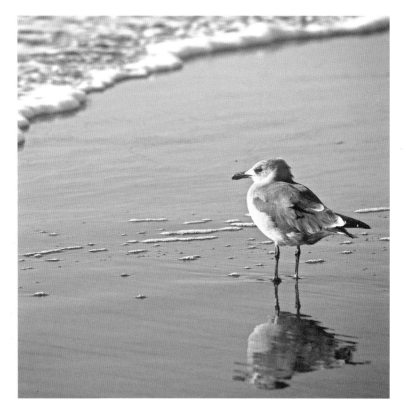

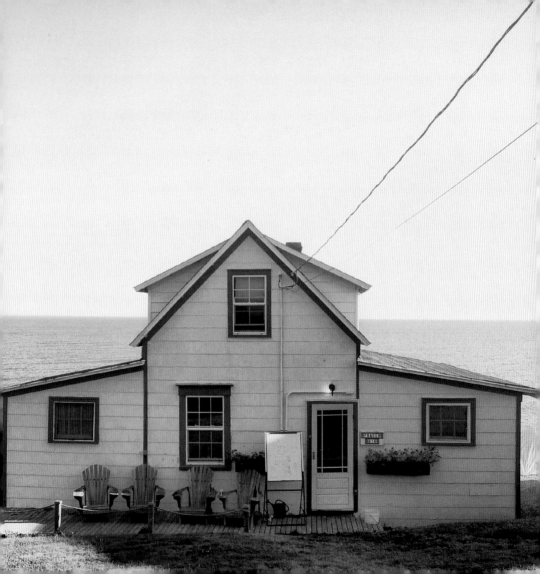

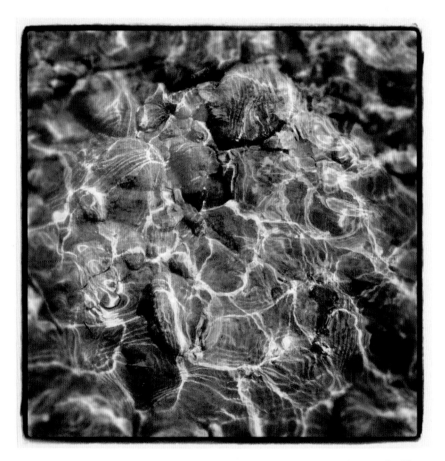

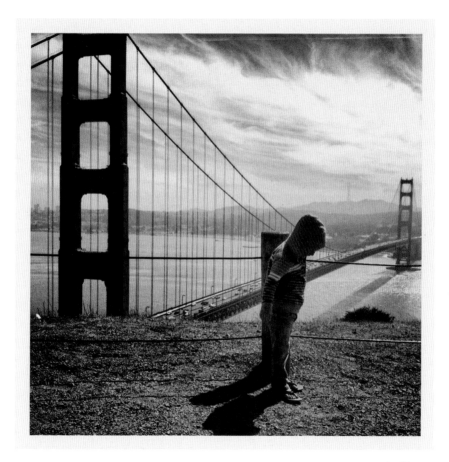

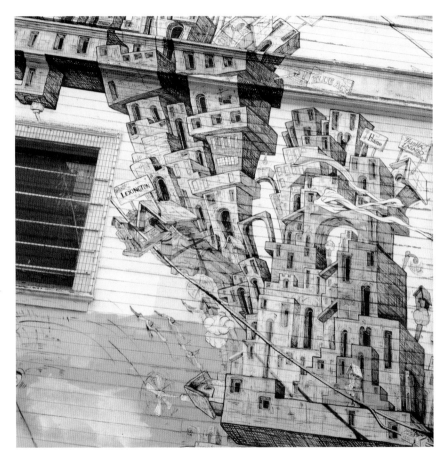

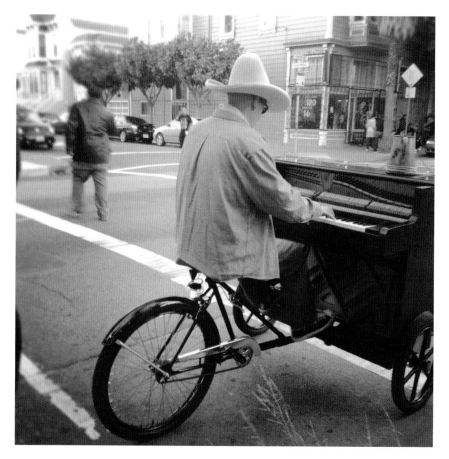

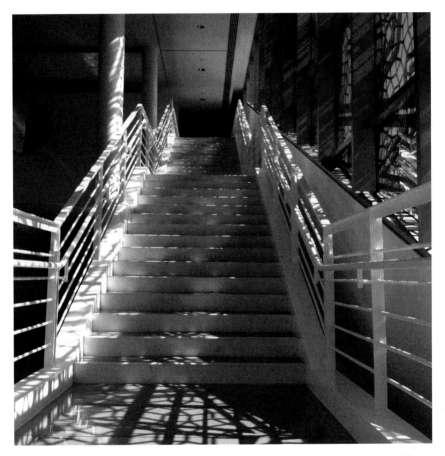

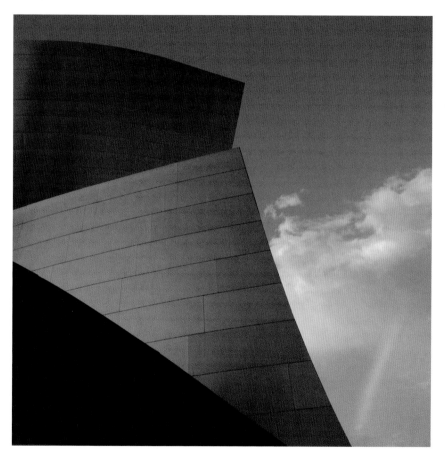

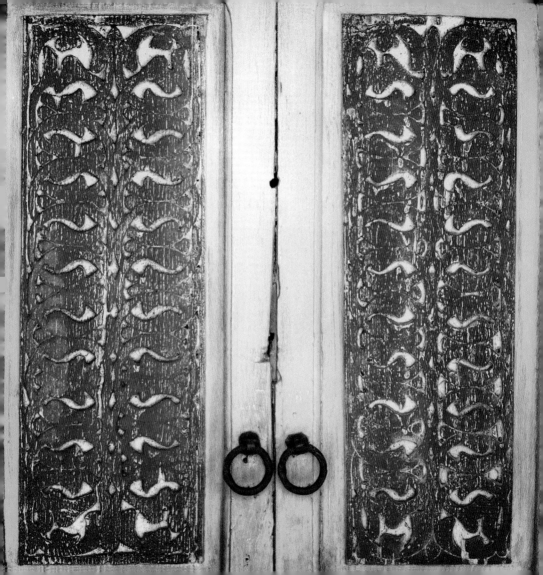

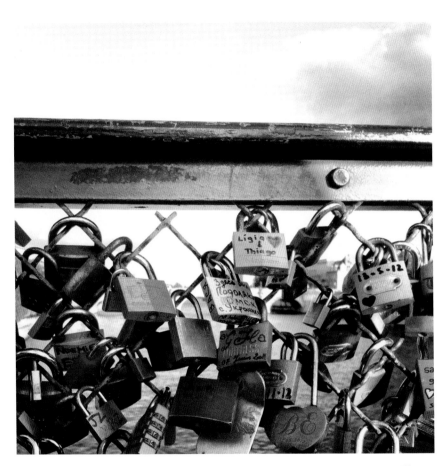

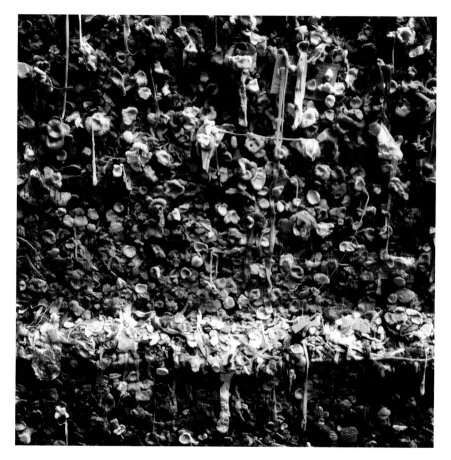

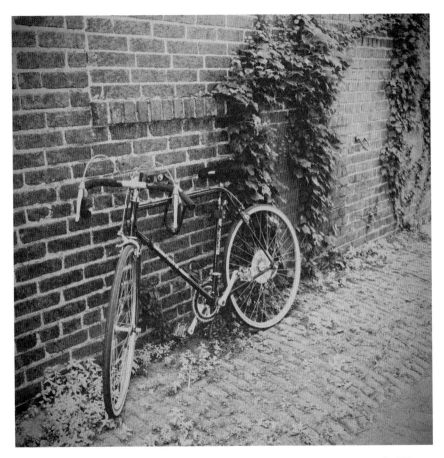

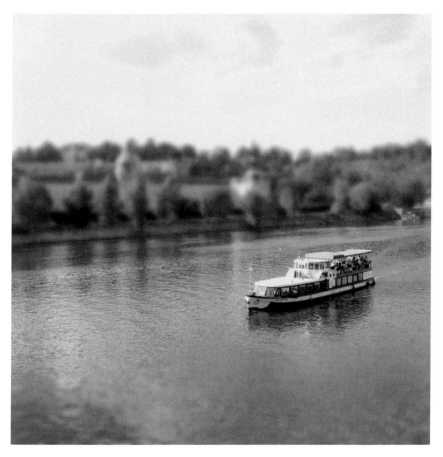

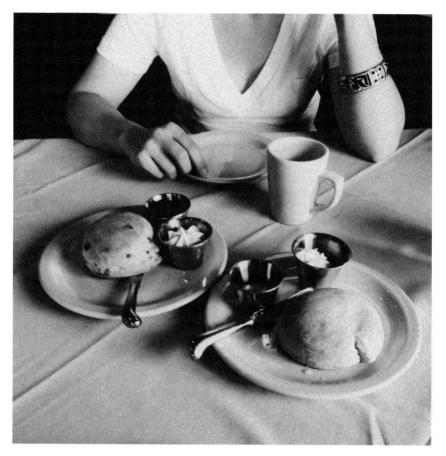

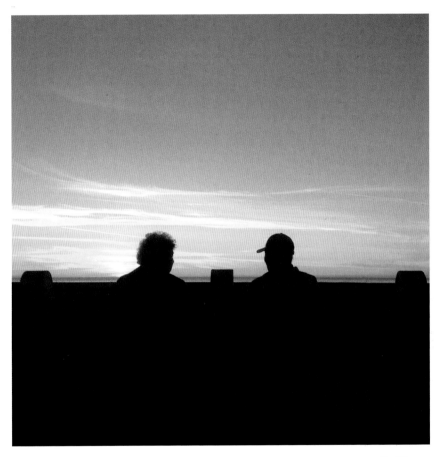

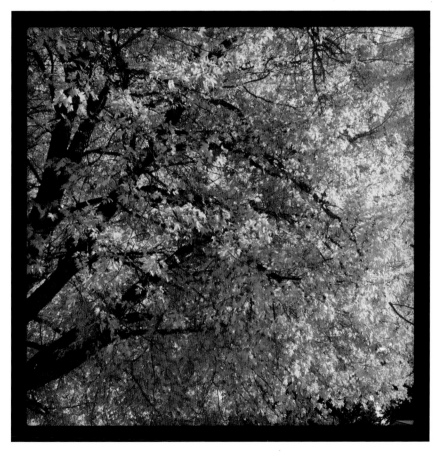

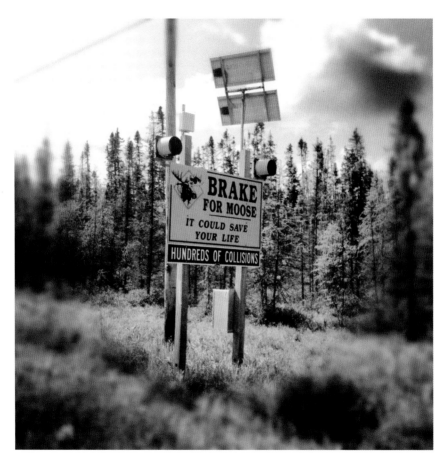

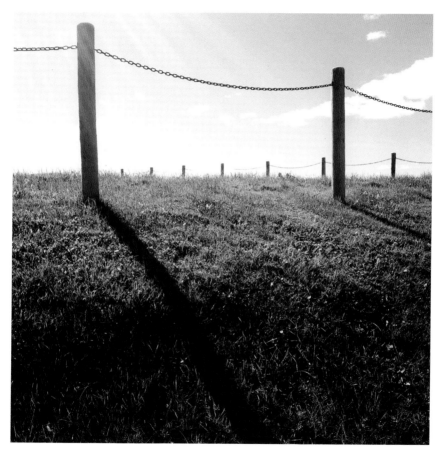

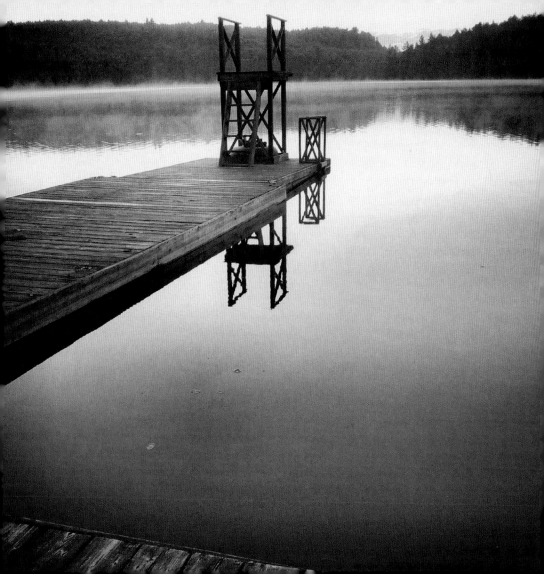

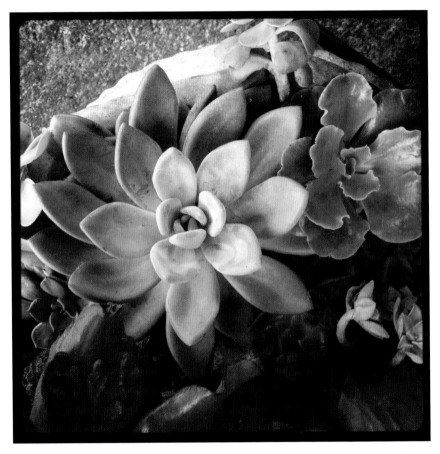

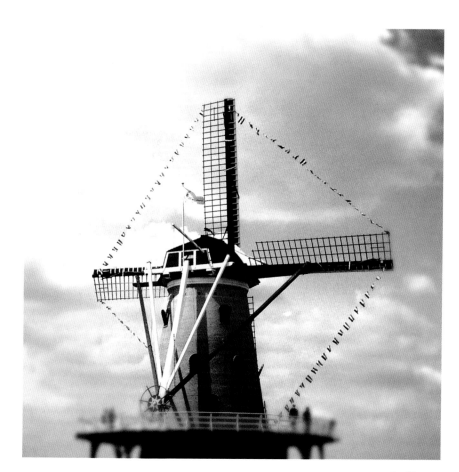

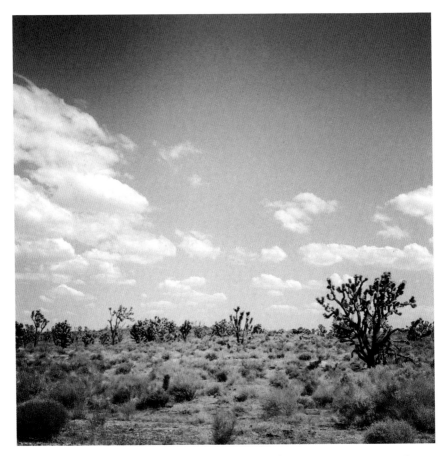

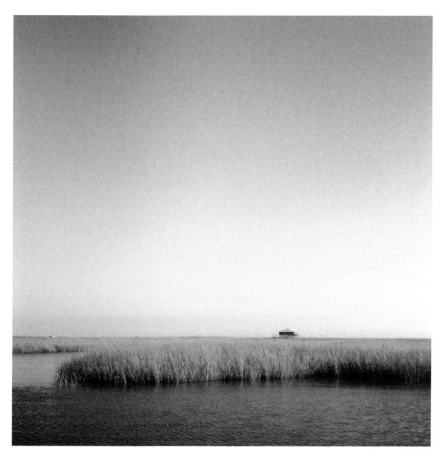

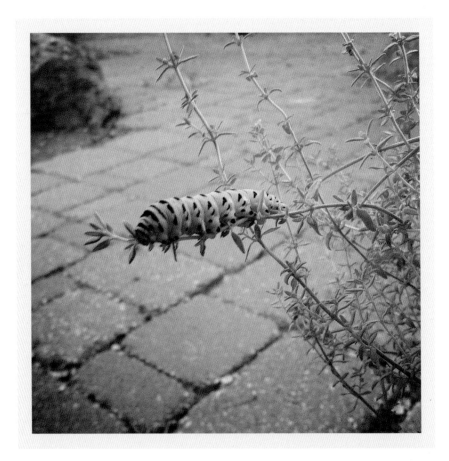

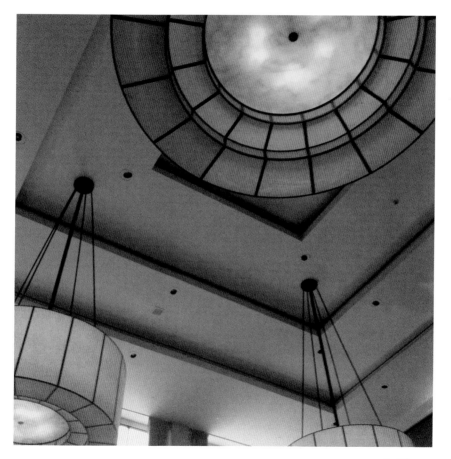

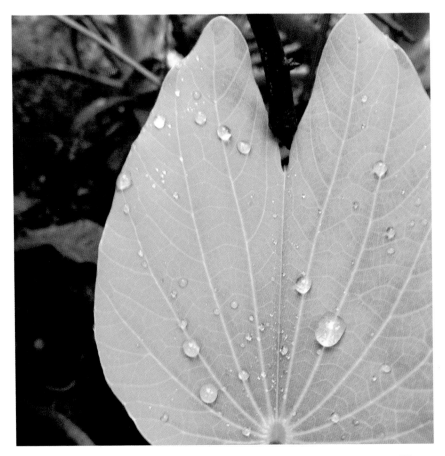

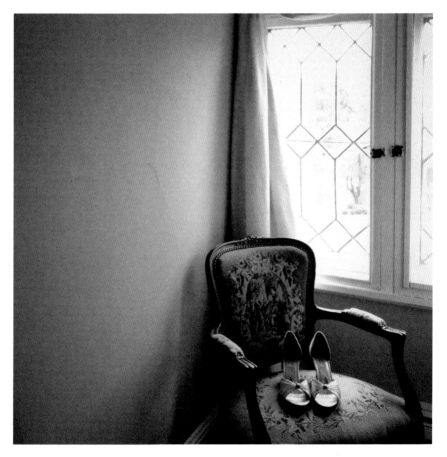

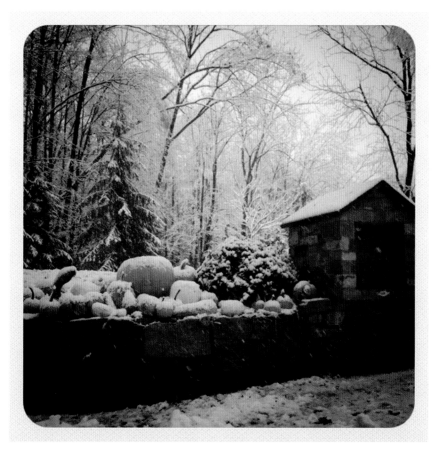

IMAGE CREDITS

31 @SARAHSHERMANSAMUEL
SARAH SHERMAN SAMUEL, SMITTEN STUDIO
WWW.SMITTENSTUDIOONLINE.COM

32 @UNSIGHTLY
REBECCA MCCLAIN

33 @BAY2
BAYLE DOETCH
WWW.LOVEFROMTHEBAY.BLOGSPOT.COM

34 @ELBEGIRL
WWW.FLICKR.COM/PHOTOS/TANJASCHWARZ

35 @FHUNG
LIE FHUNG
WWW.LIEFHUNG.COM

36 @SUSANGKOGER
@MODCLOTH
SUSAN GREGG KOGER
WWW.MODCLOTH.COM

37 @FHUNG
LIE FHUNG
WWW.LIEFHUNG.COM

38 @DONAVANF
DONAVAN FREBERG
WWW.DONAVANFREBERG.COM

39 @MEGHANDAVIDSON
WWW.MEGHANDAVIDSON.COM

40 @BAY2
BAYLE DOETCH
WWW.LOVEFROMTHEBAY.BLOGSPOT.COM

41 @ALLIEWASHERE
ALLIE HAAKE
WWW.ALLIEWASHERE.TUMBLR.COM/ARCHIVE

42 @MORGMACD
MORGAN MACDONALD

43 @MACKANNA
WWW.KOOSHOO.BLOGSPOT.COM

44 @MORGMACD
MORGAN MACDONALD

45 @PAPERANDHONEY
LAURA JOSEPH
WWW.PAPERANDHONEY.COM

46 @JESSODA
JESS DAVIES
WWW.ZAUM.COM.AU

47 @RHYMESWITHLISA
NYSA WONG KLINE

48 @BAY2
BAYLE DOETCH
WWW.LOVEFROMTHEBAY.BLOGSPOT.COM

49 @SMALLROOTS
ADRIANA BOTELLO
WWW.SMALLROOTS.COM

50 @AMY_ESTES
AMY ESTES

51 @SMALLROOTS
ADRIANA BOTELLO
WWW.SMALLROOTS.COM

52 @BRITTANYMARCOUX
WWW.BRITTANYMARCOUX.COM

53 @SARAHKATE714
KATE EINGURT

54 @BEN_MC_CARTHY
BEN MCCARTHY

55 @JOHANNALINDSAY
JOHANNA LINDSAY

56 @JENLEVIN
JENNIFER LEVIN
WWW.STUDIOTWO28.COM

57 @CIAGOULD
WWW.CIAGOULD.COM